# LAKE STREET USA

# LAKE STREET USA
# WING YOUNG HUIE

RUMINATOR BOOKS
SAINT PAUL, MINNESOTA

Copyright 2001 by Wing Young Huie

Published by Ruminator Books
1648 Grand Avenue
Saint Paul, Minnesota 55105
www.ruminator.com

First Ruminator Books printing 2001
Cover design by Jeanne Lee
Book design by Wendy Holdman
Typesetting by Stanton Publication Services, Saint Paul, Minnesota

10  9  8  7  6  5  4  3  2  1

Library of Congress Cataloging-in-Publication Data

Huie, Wing Young, 1955–
    Lake Street, U.S.A. : photos / by Wing Young Huie.
        p. cm.
    ISBN 1-886913-47-1 (pbk.)
    1. Portrait photography.  2. Documentary photography.
3. Huie, Wing Young, 1955–  I. Title.

TR680.H78 2001
779.2'.092—dc21

                                        00-066498

Printed in Canada

*We would like to gratefully acknowledge the following individuals and foundations for their generous support in the publication of this book.*

The McKnight Foundation

HRK Foundation

Bruce B. Dayton

Jay and Rose Phillips Family Foundation

"But even in this condition it is still a big modern city, and cities are the only source of inspiration for a new, truly modern art . . . The living language of our time, born spontaneously and naturally in accord with its spirit, is the language of urbanism."

—Boris Pasternak, *Doctor Zhivago*

In the summer and fall of 2000, Lake Street, a major Minneapolis urban thoroughfare, was transformed into one of the largest photography exhibitions ever displayed in a public space. In a project entitled *Lake Street USA*, photographer Wing Young Huie's 675 black and white images—ranging in size from 8 by 10 inches to 8 by 12 feet—were displayed along six miles in store windows, at transit stops, and on billboards, buses, and the sides of abandoned buildings. This epic gallery reflected the dizzying mixture of socioeconomic, ethnic, and cultural realities that encompass the dozen disparate neighborhoods connected by a singular street.

*For the last decade I've been photographing the changing cultural landscape of my environment. I grew up in Duluth, the youngest of six and the only one not born in Guangdong, China. My father owned one of the few Chinese restaurants in town and for most of my childhood the only other people who looked like me were either relatives or restaurant employees. The world I lived in was basically white, and as I spent more time away from home, even my own family sometimes seemed exotic.*

*Things eventually changed. In the early 1990s I gradually noticed that the land of the Vikings was also becoming home to Hmong, Laotians, Ecuadorians, Ethiopians, Bosnians, Mexicans, Chileans, Nigerians, Liberians, Vietnamese, Japanese, Laotians, Cameroonians, Sudanese, Somalians, Cambodians, Koreans, and Tibetans, to name a few. Walking into a crowded room and not standing out was becoming a common experience for me, especially on Lake Street.*

*On one end of Lake Street is Uptown, a trendy enclave where the Gap is an anchor tenant. The middle neighborhoods, which are the most diverse, have some of the highest crime rates in the city. Further east are the more blue-collar and middle-class neighborhoods. Jammed into that six-mile stretch is*

*the gamut of the evolving American experience, from Old World to modern world to Third World.*

*It wasn't too long after moving to Minneapolis in 1981 that I discovered Lake Street. I was fresh from a Garry Winogrand workshop and just starting to explore the streets with my camera. Those initial forays produced my first favorite street shot (bottom of page 6).*

*I went back occasionally to Lake Street over the years, but it wasn't until the spring of 1996 that I started photographing its neighborhoods in earnest. Later that fall I moved into Powderhorn Park, one of the middle Lake Steet neighborhoods, and from the perspective of a new resident I spent the next four years making photographs of the endless varieties and cultural sublayers that make up the collective Lake Street community.*

*At times the enormity of it seemed too daunting. Periodically I would become paralyzed and unable to work. Photographer's block. Even then it was rare that I left my apartment without a camera around my neck. When I wasn't taking pictures I was still composing them in my head. This made for an anxious existence, which I relieved now and then with drives to St. Paul, or any place that wasn't Lake Street.*

*I started in Powderhorn and slowly wended my way throughout the twelve neighborhoods. I relied on serendipity to show me where photographs might be made. Often people would introduce me to, or suggest, other people. It was in this circuitous fashion that I came to know Lake Street. The process was hardly a democratic one; there were certain touchstone people and blocks that I photographed repeatedly.*

*For the most part I met citizens on the street and asked permission to take their picture. Sometimes they would invite me into their homes or businesses where I would continue to photograph them. I also went to religious*

ceremonies, public and private festivals, sundry businesses, laundromats, and tattoo parlors.

It's a curious thing, I think, to be approached by a total stranger claiming to be a professional photographer. I've found that if I identify myself as an artist people take me less seriously. I try to appear pleasant and casual. I'm always slightly surprised when they acquiesce and similarly miffed if rebuffed.

Oddly, or maybe not surprisingly, the most gracious and accommodating people I photographed appeared outwardly to be the most threatening to a fortyish, middle-class, kind-of-yuppie, Chinese-American from Duluth. One half-naked, heavily tattooed man with an orange Mohawk saw me walking down the street, greeted me like an old friend and invited me to a party (page 135). A man named Psycho (the police gave him the nickname, and it stuck) actually approached me to take his picture (page 176) and later introduced me to his street family.

In September of 1999, after five hundred rolls of film (about 18,000 exposures), I started to plan how to mount 675 photographs along Lake Street's six-mile stretch of public space.

Lake Street USA was installed gradually throughout July 2000. Brochures explaining the exhibit were placed in many of the Lake Street businesses, but from the street there was nothing that told viewers what they were looking at. My name or the name of the exhibit were not displayed any-where. Photographs just started appearing on Lake Street and by August there were few blocks along the six miles that didn't have at least a half dozen pictures.

Hundreds of photographs already existed on Lake Street, but they were all advertising images. I wanted people to react innocently to my photos, with-out the distraction of artist statements or didactics. Instead, alongside many of the images were the words of the people in the photographs talking about their lives and neighborhoods, excerpted from tape-recorded interviews that I conducted, many of which appear in this book.

Reactions to the exhibit were many and varied. Two teenagers were over-heard in Uptown speculating that it must be a "Nike thing." Even after they were told about the exhibit, they remained firm in their belief that it was some sort of advertising.

Another person was relieved when told it wasn't a "memorial service to those who had died on Lake Street." More surprising was a woman who told my wife she had heard the exhibit was a commemoration for a photog-rapher who had died.

The exhibit brought a few people from the suburbs who had rarely, if ever, ventured into the inner city, but even people intimately familiar with Lake Street commented that the photographs changed the way they related to the area. "It gave me the opportunity to stare without self-consciousness," said a Korean adoptee who insisted that she never thought about "multi-cultural stuff." And by staring, it made "Lake Street" seem more friendly. I wanted to go up to the stranger that I had seen in a photo and say, "Hey, I know you!'"

One former gang member saw a photo of a rival gang and said, "These were my mortal enemies, but in this picture they look so peaceful, not threaten-ing at all. It made me look at them in a whole different way, I could relate more. I saw them frozen in time. It made me realize how human everyone is, that we aren't all that different, even though we had conflicts."

Vince Leo, Chair of Media Arts at the Minneapolis College of Art and Design, in an essay for the Lake Street USA website wrote:

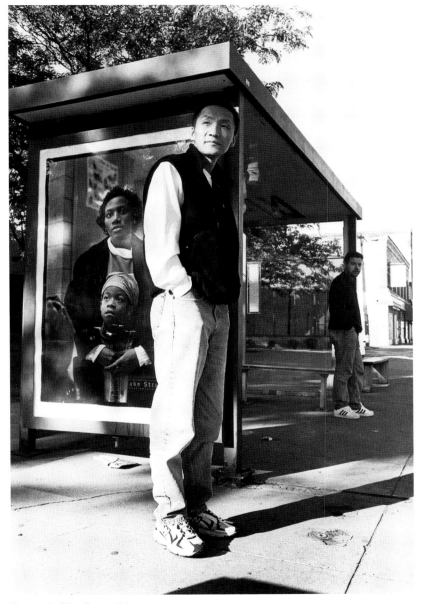

Photo credit: © Tara Simpson Huie

"Lake Street USA *is the story of how one photographer gathered all the constituents of an unidentified whole into a joint venture. It's the moment of that venture becoming a community: identifying itself, becoming conscious of itself, representing itself . . . Out of that understanding this community created something all its own, a six-mile long strip of never-ending stories, 675 moments of freedom, world-wide access to one America on its way to becoming another America."*

*Much of what comprises a community is hidden from public view. And what is publicly seen is often ignored. My hope for this exhibit was to show not only what is hidden, but what is plainly visible and seldom noticed.*

*For more on Wing Young Huie visit www.wingyounghuie.com*

**LM:** *I drove down lake street last night at dusk. I had been told that your photographs were hanging on the side of the Sears building. As I drove by there were three passersby standing in front who had stopped to look. You're holding up a mirror to the community in a way that I think is unique, in that the site of creation and the exhibition space are one and the same. The people in the photographs may pass by a larger-than-life image of themselves every day, in a sense, interacting with the work. Would it be accurate to describe this as a type of "interactive documentary"?*

**WYH:** *I appreciate and accept all attempts to describe what I do, since I sometimes seem to lack the necessary perspective or desire to describe it myself. In fact, I would rather not get in the way of other people's interpretations, although I am intensely curious to know what those interpretations are.*

*A lot of photographers shy away from the documentary label. I don't mind it so much. Every photograph is a document of something. Every photograph is also surreal. If you call me a documentary photographer than it seems to make sense to call me a surrealist too. I might even prefer that.*

*Sometimes I think of my collection of Lake Street photographs as a novel. Or a family album. I'm not sure. Even though I strive for a certain transparency in my work, I see my presence everywhere. Maybe its a document of my ideas about photography as much as it is about the inhabitants of Lake Street.*

*I think viewers are reacting more than interacting. What does it really feel like to see a huge photograph of yourself taken by a complete stranger you met on the street? Empowerment? Here's my 15 minutes? My hair looks funny? I'm going to send that photographer a nasty letter!*

**LM:** *I've always loved Garry Winogrand's work because of his sense of timing. How did your studies with Winogrand affect you? Did his work influence the way you make a picture or capture a moment?*

**WYH:** *I was around 24 when I attended the one week workshop with Garry Winogrand. It was an amazing experience. I'm still digesting it 20 years later. With his brusque wit he articulated what I was feeling, or was starting to feel at the time. Much of what he said still rings true. He was uniquely entertaining.*

*However, he was good in a way I could never be. It took me a while to realize that. I'm not even sure if I want to characterize what I mean by that. In fact I feel a little silly talking about it. All his stuff was interesting. But his best photos are among the best taken by anybody, and there are a lot of them.*

*Certainly I devoured everything I could find that he did. In my twenties and thirties I looked at everybody. I spent a lot of money on photography books and magazines. Not as much over the last several years.*

*It's hard to know where influences come from. Really, Winogrand said it best: "The way I understand it, a photographer's relationship to his medium is responsible for his relationship to the world is responsible for his relationship to his medium."*

*I really have no particular method. And I don't like thinking about process too much. Paralysis by analysis, you know. Shooting pictures is a lot like shooting a basketball for me. When it's going well the ball seems to go in by itself.*

**LM:** *Absolutely!*

*When I mentioned interaction earlier I was thinking about the difference between showing these (or any) photographs in a gallery and displaying*

them on the street. The latter seems to be so much about people coming in contact with them spontaneously which activates a whole different thought process than if you go to a gallery with the intention of looking. In that way, the show needs the streets and the interaction with the community to optimize its effect and its meaning. The audience shapes the meaning of the work day to day. In this way, it is very similar to net art, web-based art. It is alive and growing within a changing environment. This form of presentation skips over the traditional, established way of presenting art (in a gallery, museum), which is another thing they have in common. Do you think the people in this community would perceive the work the same way if it were in a gallery? Would they come to see it?

**WYH:** I can think of several differences between gallery/street presentation. Accessibility, for one. This is an assumption, but most Lake Street inhabitants don't go to art galleries. Just like most of America doesn't go to art galleries (except in malls). In a way I'm forcing people who routinely walk Lake Street to see my pictures, if only on a subconscious level. When people ask where on Lake Street the pictures are going to be I say, "Everywhere. You won't be able to avoid them."

I think having it outside also normalizes it. I mean, being in a museum legitimizes it as art, whether viewers agree or not. But outside? In a way it's a truer test. Most people see hundreds of pictures daily. We're a visually-inundated culture. But how many pictures do we see that aren't trying to sell us something? It'll be interesting to see if people do indeed notice them solely on their own merit, and think of them differently from advertisements.

Of course we'll never really know because of the media publicity. After several beers one night I was inspired with the idea of ignoring the press completely. Needless to say I changed my mind. I was passionate about it that night, however. But bringing "good" publicity to Lake Street (and myself) is satisfying. But really, what will the affect/effect be? And how can it be analyzed/quantified? I'd really like to know. The question seems too large for me. Everyone has a opinion, sure. But who really knows?

**LM:** Did you consider the different ways the public might see the work (walking by, from a passing car, out of their apartment window, in the rain, etc) when constructing the arrangement/placement of the images? How did that affect your decisions? Were you deliberate in noticing how real life would bump up against the media? Were there any conscious placements of your photographs to contradict existing signage or to reveal new meaning in those images?

**WYH:** I wanted to make the photos as large as possible so that viewers could at least get a sense of the images from across the street or in a car/bus. Most are in store windows ranging in size from 11" x 14" to 4' x 6'. The largest are on the Great Lakes Center (former Sears), which are 12 by 8 feet. We also rented ten backlit bus stops.

(I say the collective we because this project included a small army of volunteers, friends, art & community organizations, family, family to be—I'm getting married in September—and most prominently Alison Ziegler, the project coordinator, who has been working with me full-time since last fall.)

We also considered billboards, and sides of buses, but they were too expensive. (Billboards maybe too political and too high.) We may still build billboard-like structures that will be placed in parking lots. Photos may be placed on more sides of buildings or in other unexpected places. It's an organic exhibit. I might still take pictures and just keep adding on to the end.

I wanted my pictures to coexist with everything else out there. I was worried that Lake Street would swallow 600 photos, but at the same time I was conscious that I was adding to the clutter.

We tried to mix up the photos as much as possible and think of Lake Street as one big neighborhood. But we also made an effort to put many of them in areas where they were taken so that the people in them would see them. (One person called me and specifically requested that their picture be as far from their neighborhood as possible.) We tried to avoid anything that would appear to be too didactic, but at the same time we wanted to have fun and maybe tweak some noses.

LM: *Is exploitation a concern of yours? Being perceived (either by the community or by the public at large) as opportunistic by using the folks in the community as subject?*

WYH: *Exploitation? Sure, I carry around a certain amount of guilt. It comes with the territory. I tell myself that they are just photographs. Everybody has photographs of themselves, even ones that they don't like. To tell you the truth I don't like thinking about those things too much—it might stop me from working. I try to be responsible to what I'm photographing, and I draw lines, but sometimes the lines get blurry. There are photographs I took that I think are powerful that will not be included in this public exhibit.*

LM: *When I used to go out into the streets to photograph, I sometimes couldn't bring myself to take the picture I wanted to take because it somehow seemed invasive to me. As if I was looking at the subject as a specimen, as somehow existing outside of my world. Especially if they are in a vulnerable or emotional moment. How do you deal with a very private moment, in a church for example, when those moments are the stuff of wonderful photographs. It's what you dream about!*

WYH: *Some situations are too intimate for me to photograph. And I don't like showing anyone's misery just to show that people are miserable. I like what Arbus said: "I don't particularly like dogs. Well, I love stray dogs, dogs who don't like people. And that's the kind of dog picture I would take if I ever took a dog picture. One thing I would never photograph is dogs lying in the mud."*

    *Churches are great to photograph! I always ask permission from the person in charge who then tells the congregation. I've never had a church refuse me. They want my soul. I want their pictures. It's a fair exchange.*

    *I think people often collaborate, consciously or subconsciously, when I take their picture. I don't know if this is true, but I sometimes get the feeling people pray harder when I'm photographing them.*

LM: *In Vince Leo's essay, he mentions that with this project, "the community has a stake in its own representation." I think this is the essence of true interaction. There are the things that the people themselves have written that accompany some of the photographs, which to me, is a complete contradiction of what a traditional museum or gallery does, which is to keep people at a distance—to just observe.*

WYH: *Accessibility breeds interaction. Interaction is about acceptance. When I put up my photographs in Frogtown in an outdoor lot, people told me that it was a crazy idea, that it would be down the next day. In a way I thought that once they were up they weren't mine anymore. That they existed like any other structure in Frogtown. I was a curious observer like anyone else. Surprisingly they were not enhance/defaced at all. There were some pictures taken, but I think those were by the people in them.*

LM: *Peter Ritter, [in an article in the Minneapolis weekly newspaper City Pages,] mentions the possibility of someone taking a black marker to one of your photos on the street. Would you look at that as an enhancement or a defacement? Or just part of the risk you take in placing things outdoors?*

WYH: *With Lake Street I feel a little more of an ownership, plus it's a large-scale collaboration with 150 businesses involved. I think when possible we will remove any markings of street art critics.*

LM: *Your attitude of "letting go" of the work after you've finished and giving it back to the community is very holistic. This draws another parallel to net.art which often generates its meaning from this kind of organic process. Each viewer shapes, to some degree, the meaning of the work and the "art" is a flexible idea.*

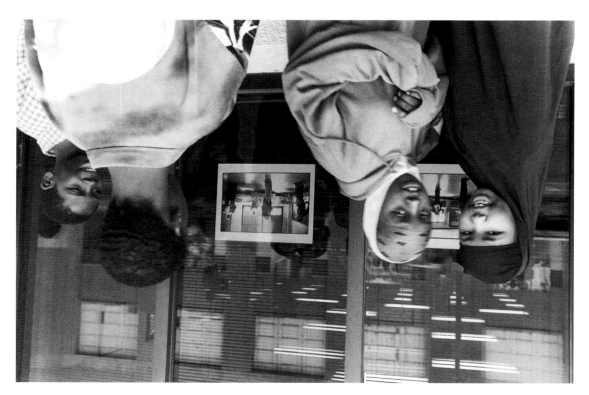

**WYH**: I used to place more importance on the photograph itself. Like it was some prize trophy. Working on Lake Street I made a conscious effort to enjoy the process more. ie., when I interacted with someone I tried not to get anxious over whether or not I'm going to get a good photograph out of it, and instead tried to enjoy the conversation. (It was somewhat successful.)

**LM**: Do you perceive a shift in the consideration of art toward this notion of flexibility, where less meaning is placed on the thing itself than on the experience it generates for the individual? Or is it nothing new? (ie., Fluxus, Happenings, etc...)

**WYH**: I like the idea of being thought of as a Fluxus artist (although I'm not completely sure what that means). Because I usually ask permission first, the photographic act for me is a kind of dance, although most of the time I lead.

*Used with permission of the Walker Art Center.*
*www.lakestreetusa.walkerart.org*

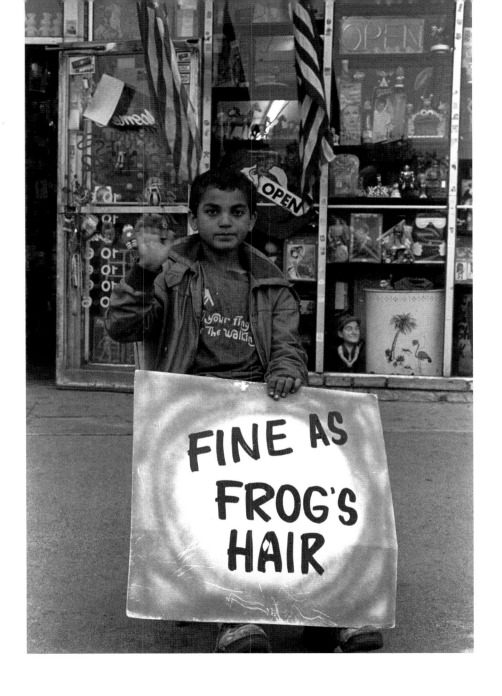

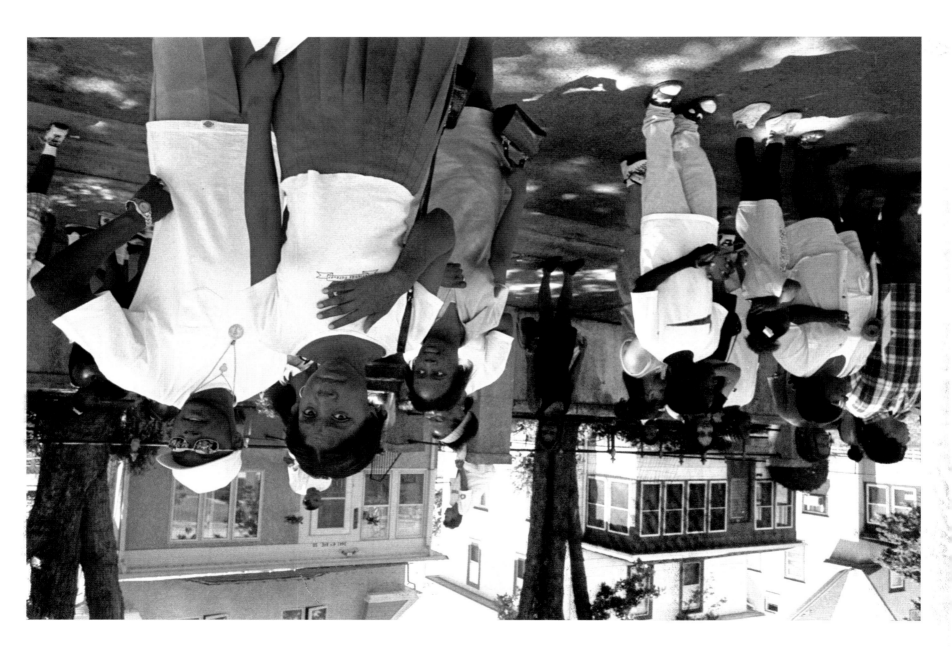

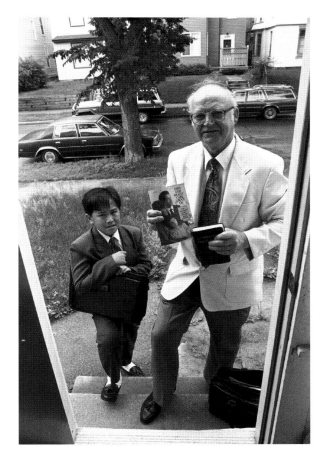

We call it witnessing—you know like at a jury trial when you get a witness for the defense. That's why we're called Jehovah's Witness, because we witness for Jehovah. We offer hope for the future. Conditions are not good. I see how miserable people are. The poverty, drugs, you name it. It's Babylon. Religion has divided people. There are twelve hundred different religions in the United States alone. People are confused. That's why we're out there.

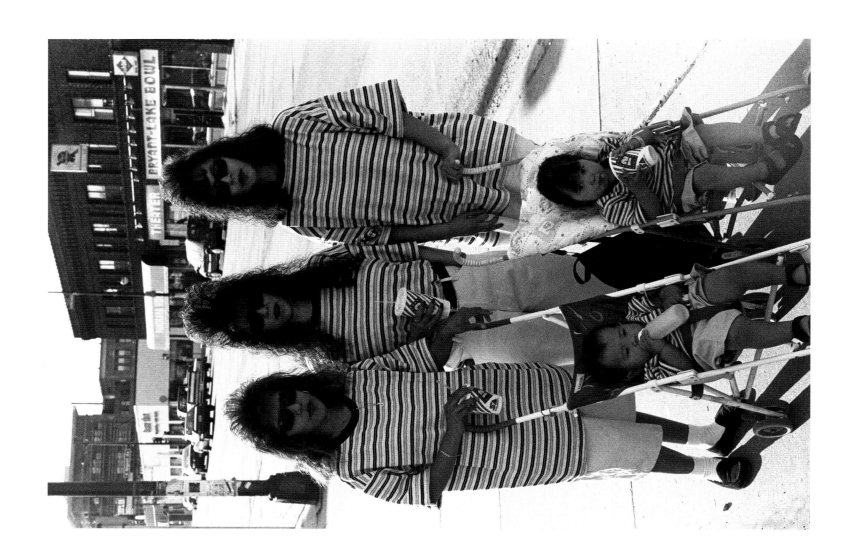

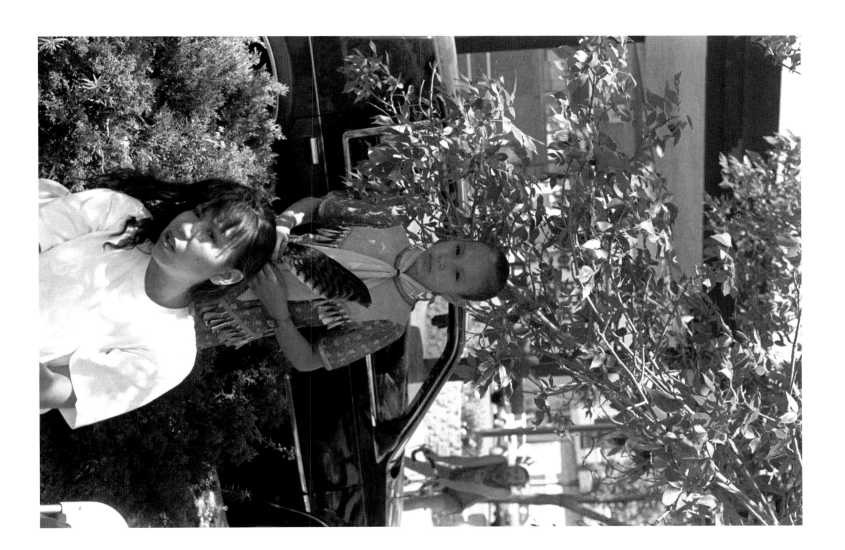

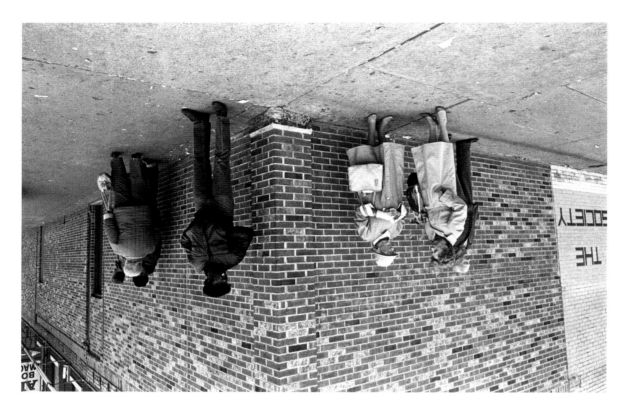

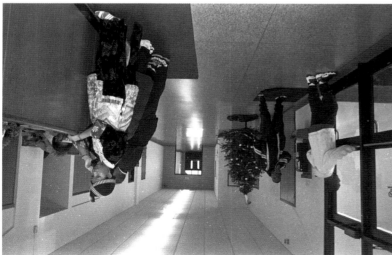

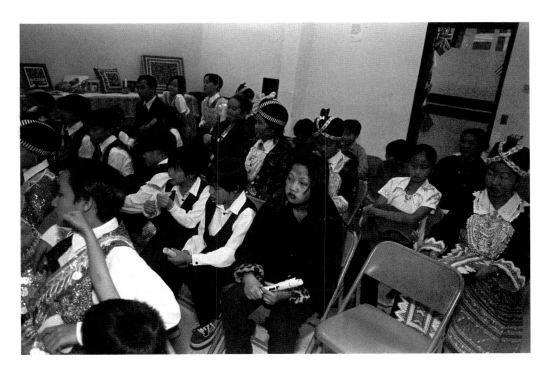

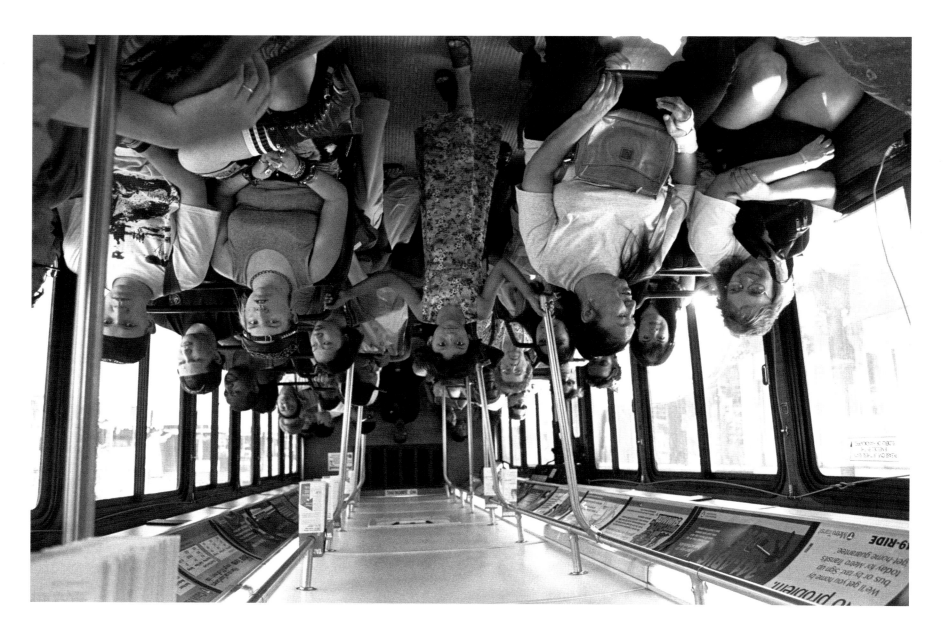

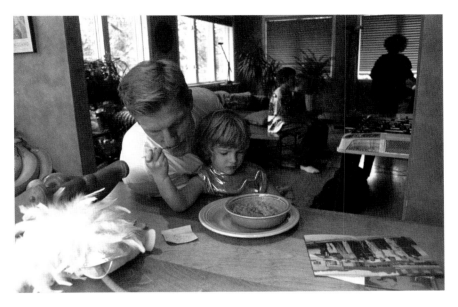 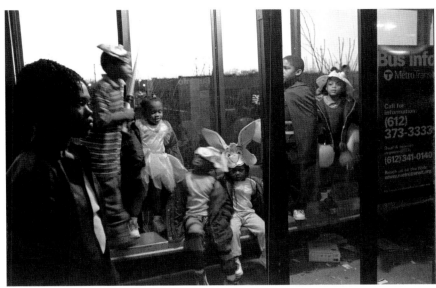

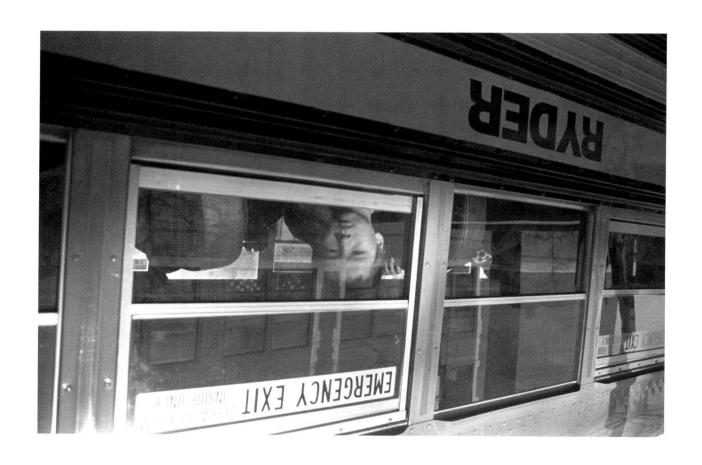

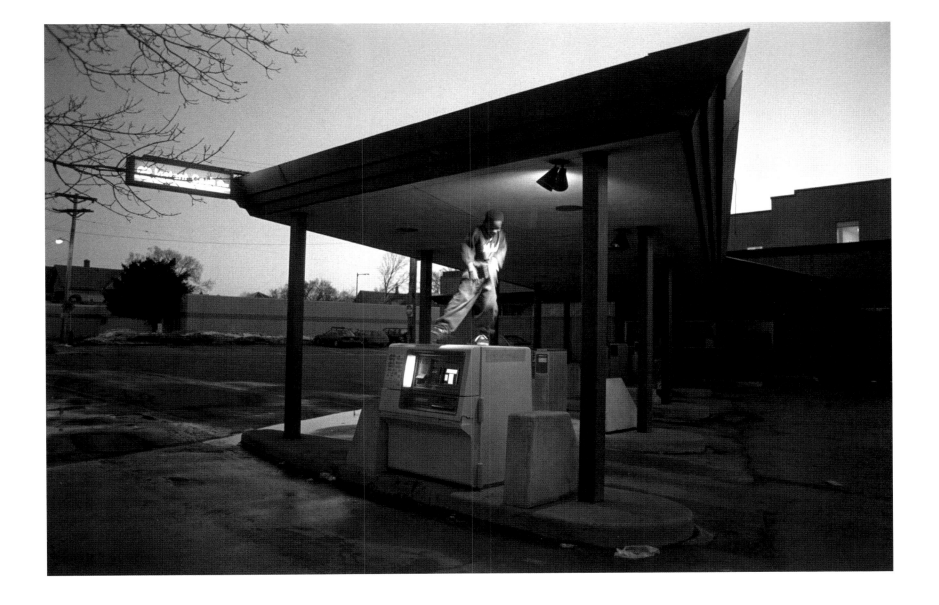

She's quite the dresser-upper. She wore a different outfit every day in nursery school. This was just another one to add to her huge collection of dress-up clothes. Her spirit is so pronounced. She would go to nursery school with her gown, and it would be filthy dirty because she wouldn't let me take it off to wash it. She would sleep in it.

For her nursery school picture, she wore the most incredible wig. She was four years old. She had the foresight to say to me, "Tell those teachers that I can wear the wig for the picture." I told them, and they said that they were glad because they wouldn't have let her wear it otherwise. The picture is such a scream. Because of that class picture, she'll go down in history at the Temple Israel Nursery School.

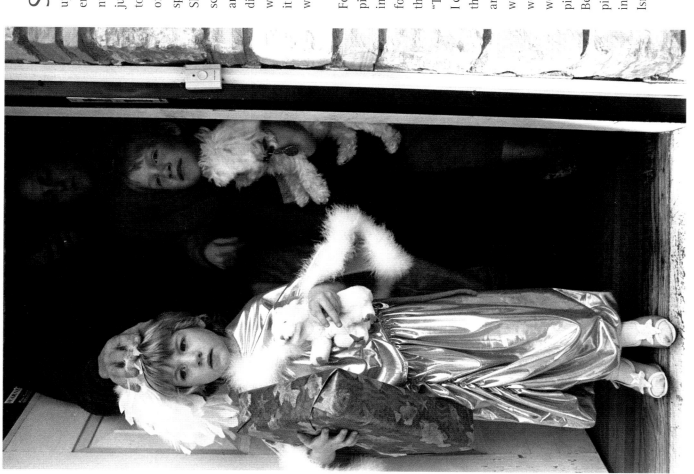

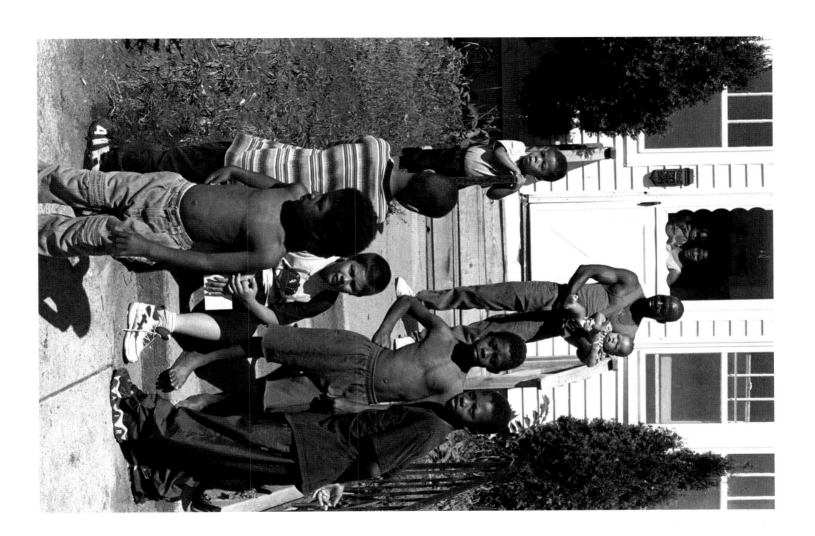

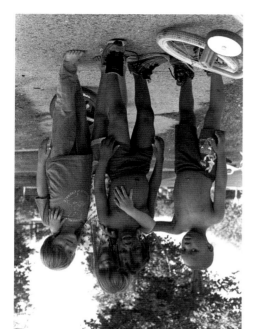

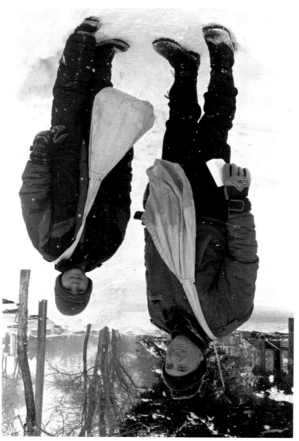

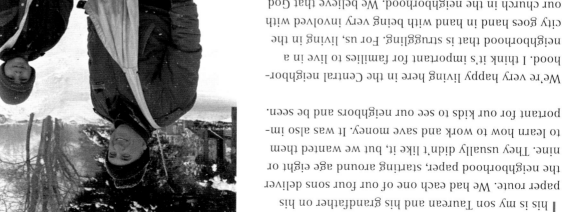

This is my son Taurean and his grandfather on his paper route. We had each one of our four sons deliver the neighborhood paper, starting around age eight or nine. They usually didn't like it, but we wanted them to learn how to work and save money. It was also important for our kids to see our neighbors and be seen.

We're very happy living here in the Central neighborhood. I think it's important for families to live in a neighborhood that is struggling. For us, living in the city goes hand in hand with being very involved with our church in the neighborhood. We believe that God can use us here more than he could in the suburbs.

It's important for us to live in a diverse neighborhood because we are a biracial family. I believe that biracial relationships enrich life. Even though it's a pretty liberal area, we are always conscious of how other people see us. People treat my husband differently. For instance, if we want to return something and we don't have the receipt, I will return it. I know they will give me the money and not my husband. There are just some things that we know that it's better to do.

*Taurean:* I don't really think about being biracial a whole lot. I'm not really uncomfortable with it. There are always some people that look at me different. You get used to it. My friends and I just accept it. We don't need to talk about it. I think adults talk about it more than us. We don't really care. It's there, it happened and that's it. You can call this picture *Little Kid and His Grandfather Growing Closer Together.*

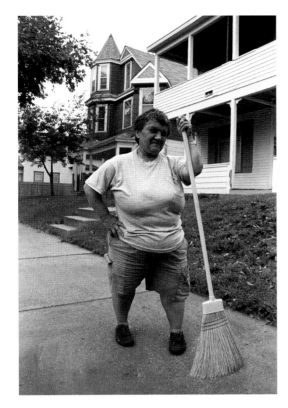

When I first moved into the neighborhood, the people got along really well. They looked out for each other. We didn't have to fear for the people coming into our neighborhood who didn't belong here. Now you have to turn around and watch who's coming down the sidewalk behind you. People don't want to be involved. They just as soon as have somebody else do all the dirty work.

The neighborhood has gotten to the point where unfortunately I can't tolerate some of the activities going on anymore. I've been threatened by some of these people. I notice a lot of drug activity and prostitution. Some of these people are aware that I'm aware of it, so therefore they know that I've been talking to the police and they say to me, "Hey, we're going to eliminate you." I don't like to say it, but it's just not desirable to live here anymore. I'm moving to the suburbs.

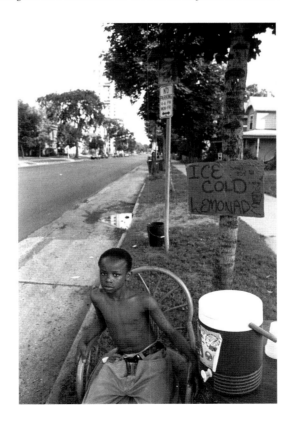

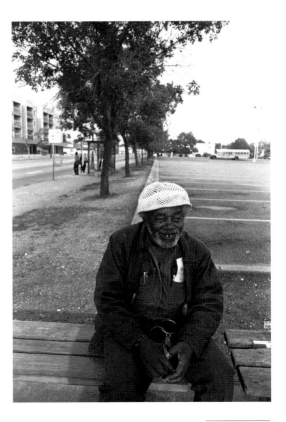

There are seven of us kids in the family. We're going to use the money to buy some clothes and outfits for the Fourth of July for all of us. If there's money left over we're going to buy more supplies for more lemonade.

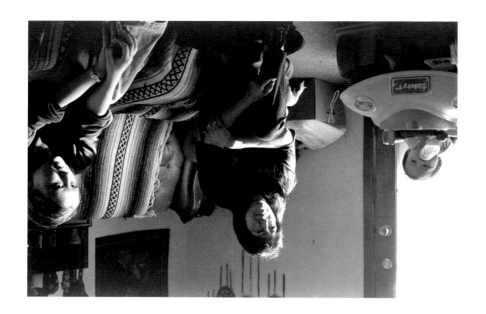

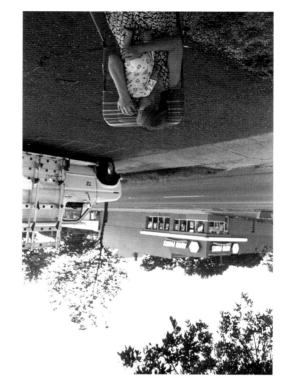

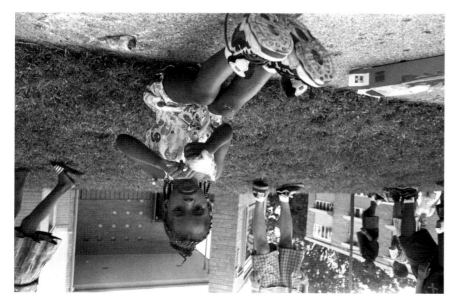

People shop here just like the way they did in Mexico. They come twice a week, buy their tortillas, vegetables, hot peppers, and spices to prepare the food they are used to. They bring their whole family. It's a social thing, a community. People have met their fiancées here.

There are many other Latino businesses. There are video stores, jewelry stores, clothing stores, everything. People come all over, from far away, to shop on Lake Street. From Bloomington, Richfield, Saint Paul, even Duluth.

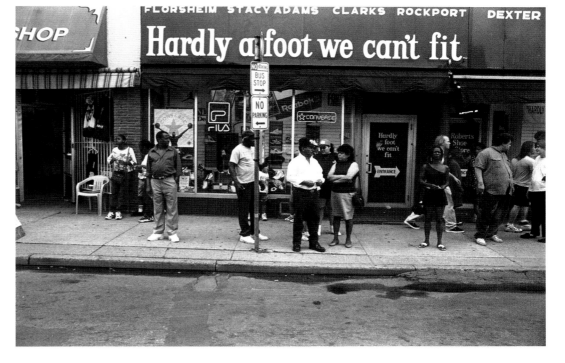

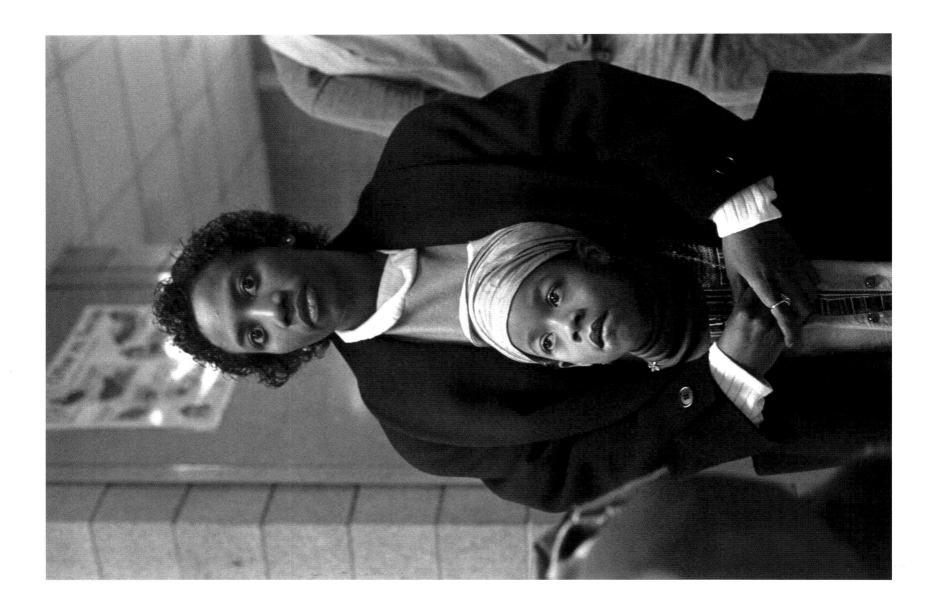

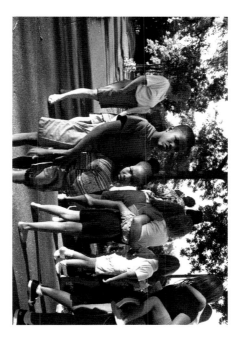

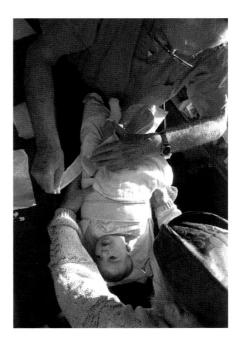

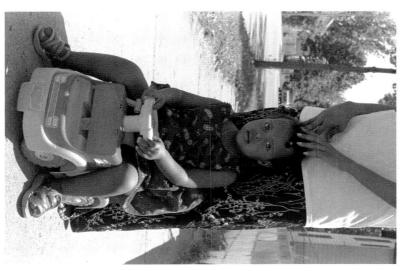

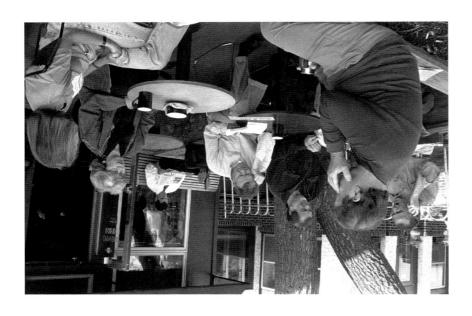 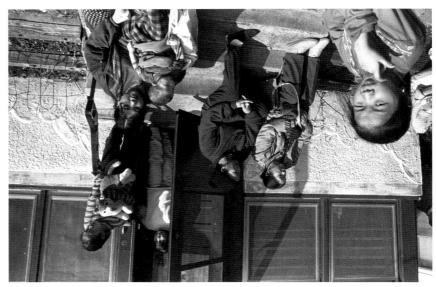

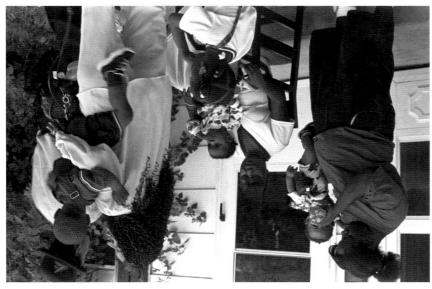 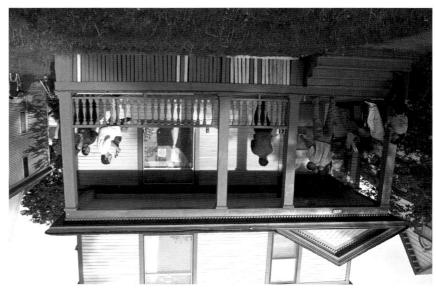

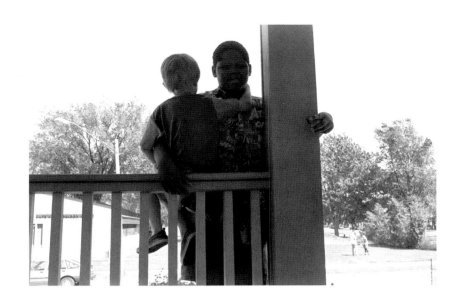

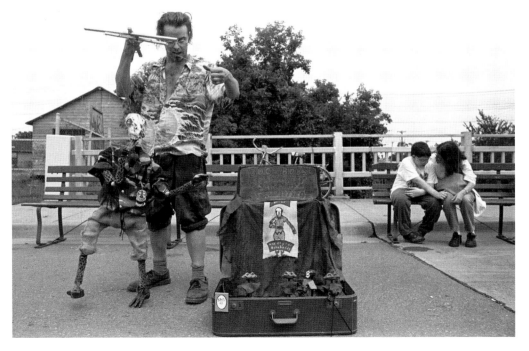

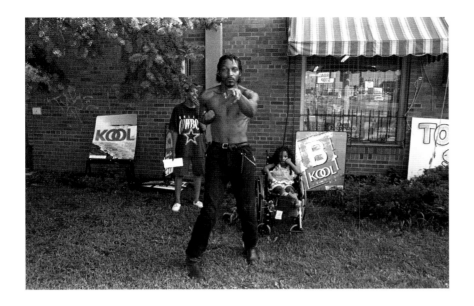

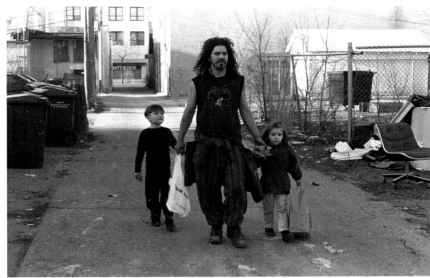

When I moved here from Iowa, I had no money and no relatives, but my martial arts kept me going. It has helped me stay on the straight and narrow and not get into drugs or alcohol, which I had a problem with. The martial arts I practice is the physical expression of the *I Ching,* the oldest book in the Chinese culture.

The Chinese, in my opinion, are the most civilized of the nations because they have a philosophy that is unbeatable as far as morality and ethics and decency. I want to spread my martial arts and actually teach it back to Chinese, if they will accept that.

I give praise to whatever deity it is, whether it be Buddha or Jesus or Allah or whoever. I love all people, all cultures, all ethnic groups. God first, then country, then children, then self. Thank you.

I make a conscious decision to walk in alleyways with my children. Alleys are so lush and green in the summer. They are quieter and always full of mystery and surprise to the open eye. We catch monarch butterfly caterpillars on wild milkweed and raise them in safety until they hatch. Then we set them free to the wild. Most of all we like to find stuff to make art and puppets out of. It's like a kind of recycling or alchemy to transform junk into a beautiful puppet that dances and breathes.

We always run into an eccentric old man in the alleys around here who reminds me of my grandfather. This old guy also turns trash into treasure. Every time, he tell us the story of a nuisance pile of rocks that laid around until someone came along with a vision to build a cathedral.

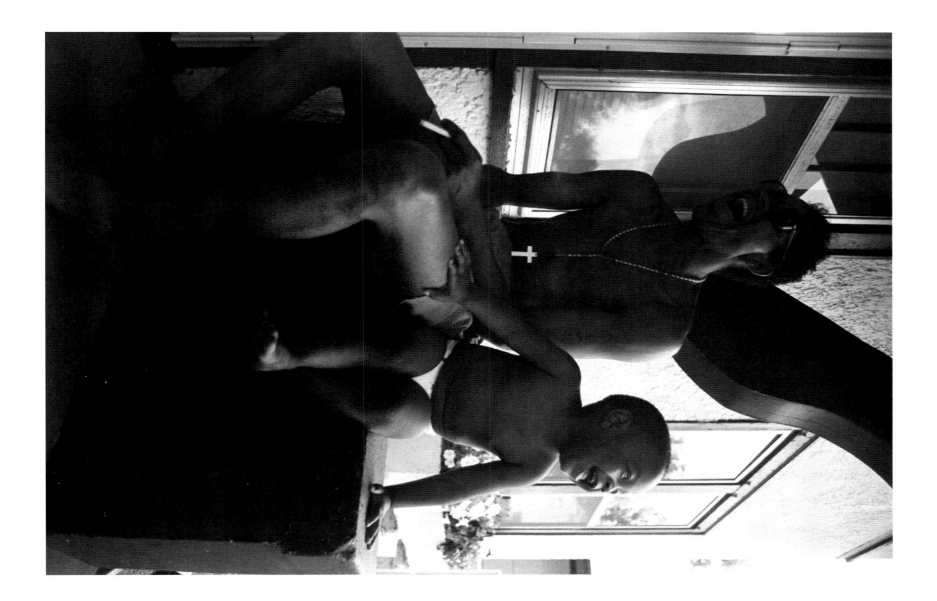

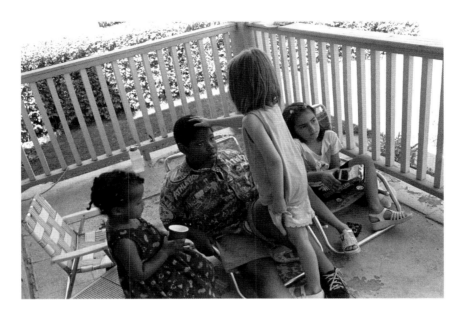

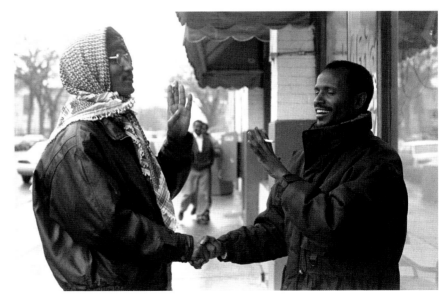

I've lived in different places on Lake Street most of my life. My mom works the streets. It's kind of depressing what turned out to be. I never seen it coming. But life goes on, I guess. I try to see her all the time. We're always happy when we're with each other though. I take her out to eat when I can. Last payday I gave her forty-five dollars and told her to do what she wants with it.

I come to the Peace Garden often in the summer and the spring. Sometimes I'll just go to relax. It's kind of hard to relax there now because it's kind of messed up. There are beer cans all over, but I did a little part of it too. I guess everybody did their little part. I just lay on the bench and medi-tate. I try to think about peaceful things, dreams, and hopes. Things like getting my own apartment, getting on with my life. I hope that my mom gets off of working on the streets. I sure wish I had a regular family once again. That's my hopes and dreams.

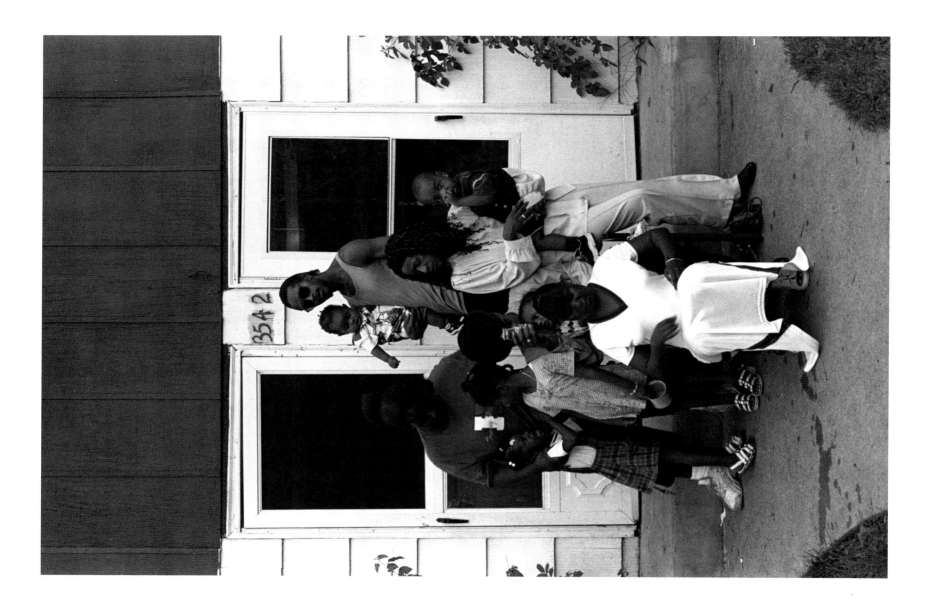

We had been married for about ten years when we opened the restaurant. We separated several months later. She's been working for me ever since. She does all the cooking. We're both remarried. We always got along.

I eat all my meals here. I made the restaurant out of a garage, added doors, and just kept adding on. I

worked on the railroads for thirty-eight and a half years. I was retired, on a pension, when I decided to open. Didn't know anything about the restaurant business. I only planned to keep it for about three months and then sell it. I named it the Diner because when I sold it the new owner could then just add their name, like Harvey's Diner. But I kinda liked it so I never did sell.

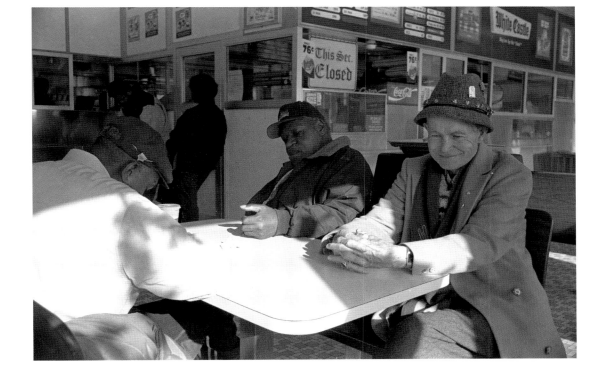

There's about a dozen regulars that came down here every day. Just your average everyday people. I've been coming for fourteen years. A lot of the friends that I met here have died. One friend just got killed. Car accident. Killed him and his son. James was the same age as me, sixty-eight years old. Then there was old Tom. He was about eighty-eight. And Andy, he was a good friend of mine. He was seventy-eight. Diabetes. My barber Cliff. He was eighty-eight. Heart attack.

It's sort of like a meeting place. We sit around, have some coffee, and BS. Do the Daily Three, argue, and all that crap. I don't know why we chose White Castle. It's no more special than Burger King or McDonald's.

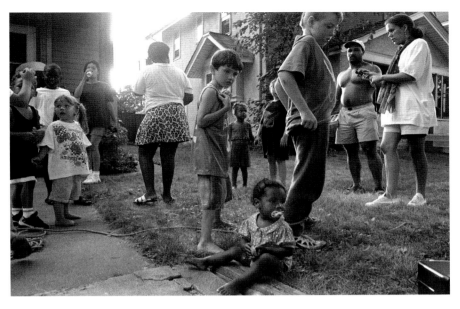

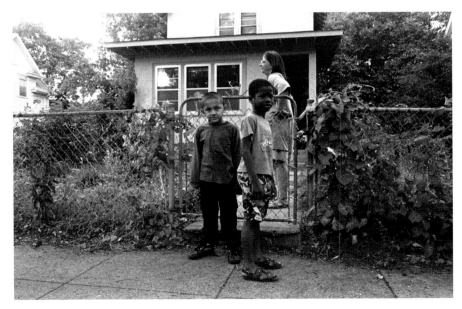

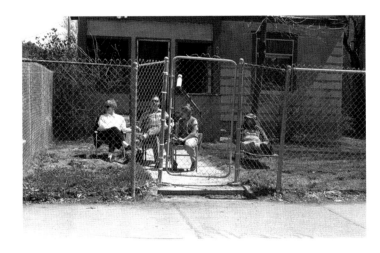

I want to be a professional football player. But if I don't make it, and they don't draft me in college, then I want to be a criminal lawyer. Then work my way up to a judge.

I've wanted to be a lawyer since I was six years old, when I seen that O. J. Simpson trial. I didn't think that O. J. did it. He was all happy when they found him innocent, and I want to make people happy. Any kind of folks, no matter what color they are. Being accused of something you didn't do can cause a lot of stress.

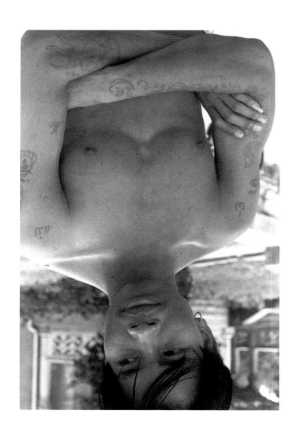

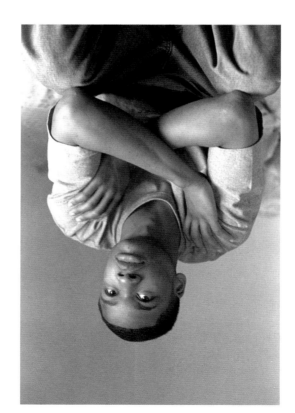

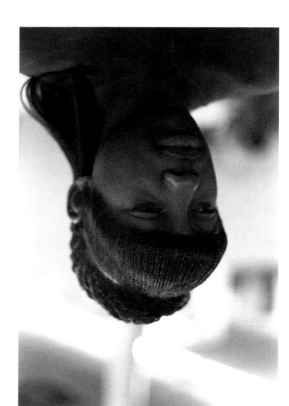

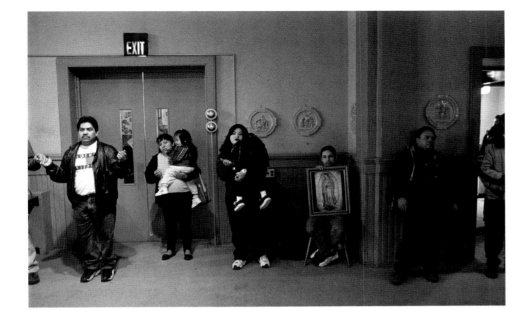

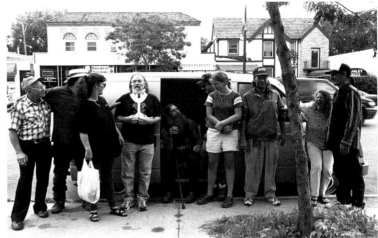

*Saint Stephens Church has one of the largest Latino congregations in the area. Up to two thousand come every weekend to the three services, all of which are in Spanish.*

We are here to help the Latino community in a special way, to let them know and feel the dignity that they've been given by God. We are seekers of justice. We believe that everyone has the freedom to emigrate, that no one is illegal. Maybe undocumented, but not illegal.

We are in the process of helping people to find support in this country for their being here. Their rights are constantly being violated. They're invited to come work in your hotels, your restaurants, your factories, and your slaughterhouses. They take the jobs that other people don't want. These people come and keep the infrastructure alive. Then they come and face racial profiling. Discrimination in housing. They are stopped and asked for their documents. It's endless.

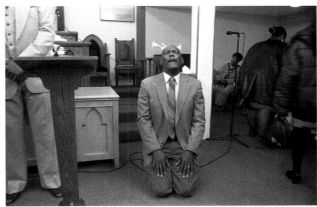

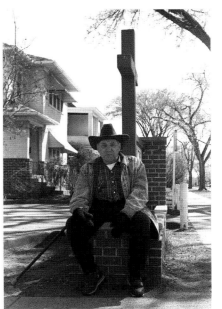

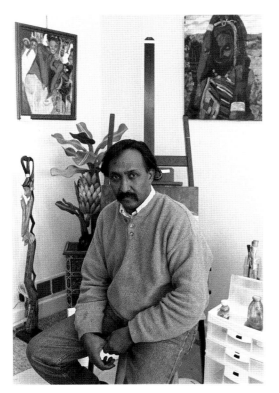

When I came here in 1991 we were eight or twelve. Now there are more than 40,000 Somalians in Minnesota, the largest Somalian community in the United States. People were friendlier when we were few. They would say hello to you. Now they think we are here to steal jobs.

I've lived in Europe. It's different there. People are kind. Very. They invite me to dinner. They are curious. They want to know about ethnic people. After one week I have friends already. I am more than ten years here and I have only one American friend.

The only thing that makes me happy is my painting. It is a bridge to my homeland Somalia. It is a gift from God and I use it to survive. Living here is not easy. No one helps you. The banks don't help you. I've been six years in a high-rise building. Everyday they are coming, the police, harrassing the people. I feel I'm trapped here.

There are good things. It's a beautiful country. We live peacefully. There are no dictators. We are free. I'm lucky because sometimes I get grants to teach art in schools to Somali children. I'm grateful to be here.

The only future we have is to go back home. The Somali born here are different. They think United States is a good place. They don't know Somalia. They don't know Africa. They don't know other alternatives. The only thing they know is United States, Minnesota.

May 16, 1997, was the most joyous day of my life. It's a once-in-a-life-time experience being in a beauty pageant. I remember walking in there and seeing all those other girls and thinking, "No way." I don't look at myself as a beautiful person, but everything about me is natural. I'm not a phony. I could laugh and smile like it was no big deal. I looked at the judges and all the people like old friends.

One of the questions they asked me was "If you could explain yourself as an animal, what animal would you be?" I just bluntly came out and said, "A butterfly, because it's such a beautiful creature. Even if it's the meanest person, I could land on them and make them smile." I was the first Miss Lake Street. To this day, I'm still called Queeny or Miss Lake Street. I'm a living legend.

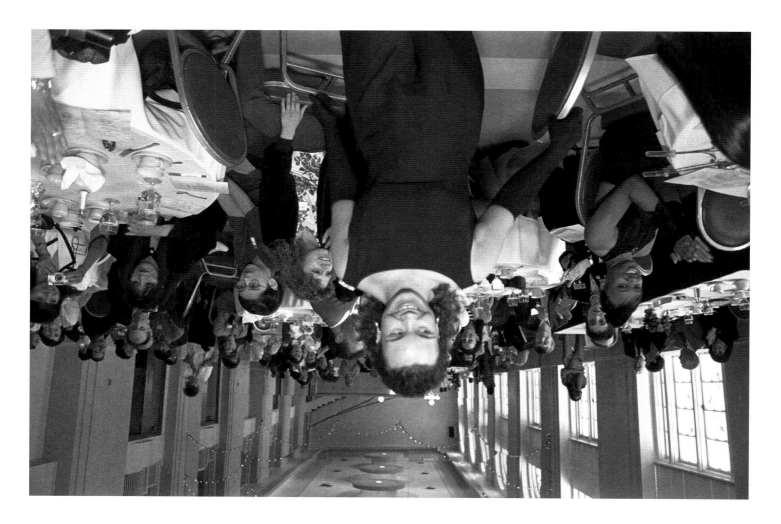

In Somalia people say, "When you are going to America, you're going to paradise." But it's not paradise. It's just like Somalia. The difference is there is no civil war in America. There is more education here, more technology. But it's not paradise. We lived in a big city, in Mogadishu, the capital of Somalia. It's so sad. A lot of people died. My uncle died. My big brother died. Some guys came and wanted to take gold or something. We say we don't have, but they don't believe us. So they killed him.

I like to write. Most I like to write about how people are different. The difference between Christian religion and Islamic religion. Another difference is how people dress. If you are Muslim, you cover your whole body. In Somalia if a woman wears pants, they say she is crazy. She becomes like a man. They will chase her. So when I came to America and see a lot of women wear jeans, I get confused. It's a different culture. Most Somalian girls who come to America dress like Americans. I will never dress like that. I don't want to break my religion.

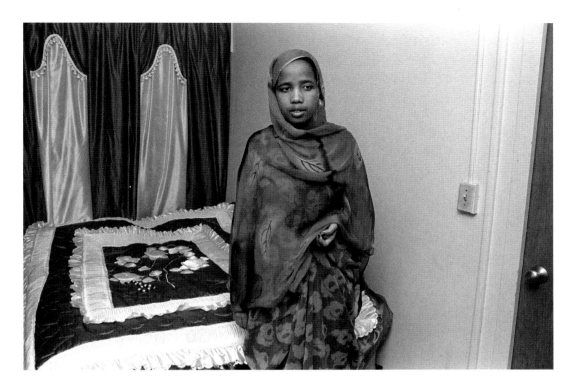

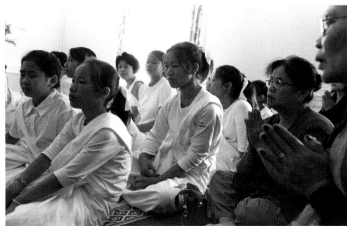

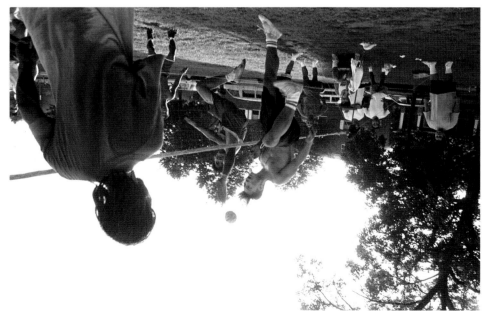

Powderhorn Park, on any summer Saturday, is pretty much divided ethnically by different sporting activities, each staking out their own area of the park. There's an outdoor basketball court (African American), a makeshift soccer field (Latino), a tennis court (white), and this kator game (Laotian). Kator is the Laotian word, but internationally it is officially known as sepak takraw. This incredibly acrobatic game is popular in southeast Asia—Thailand, Myanmar, Laos, Cambodia, Vietnam. It's like a combination of hacky-sack and volleyball, except instead of using your hands, you use your feet, knees, elbows, shoulders, and head to kick a rattan ball.

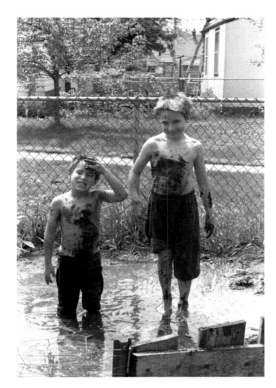

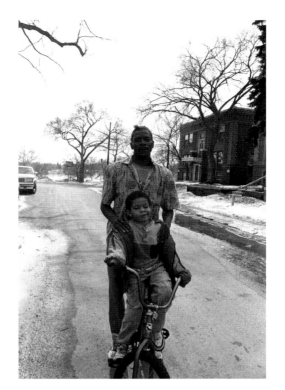

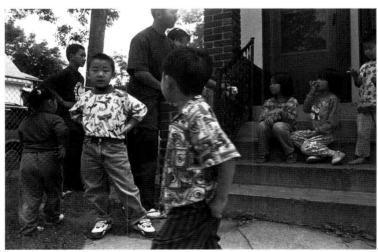

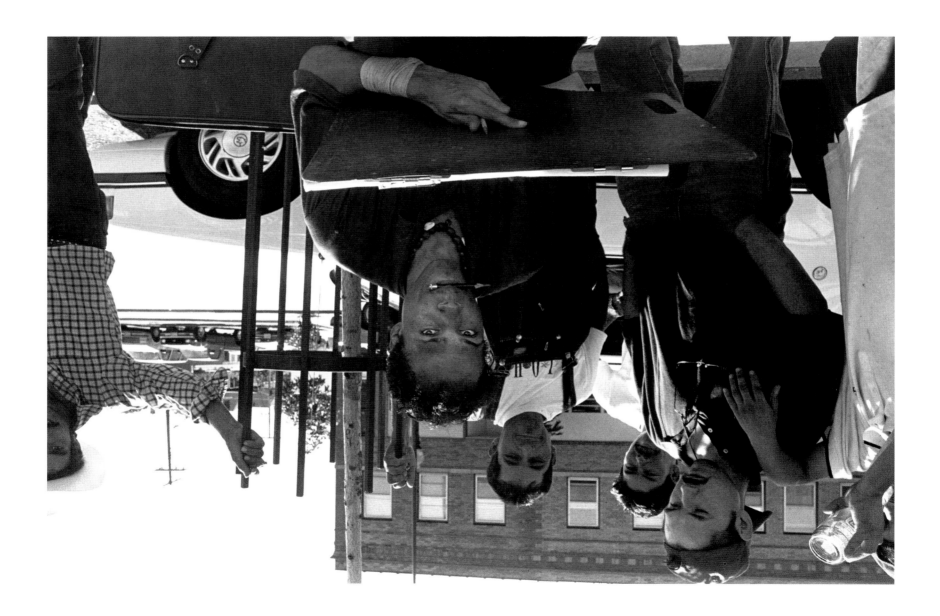

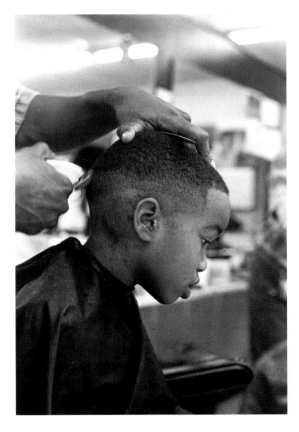

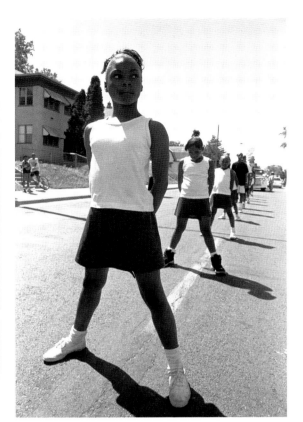

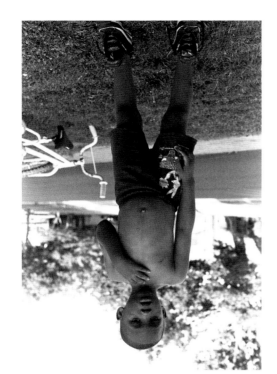

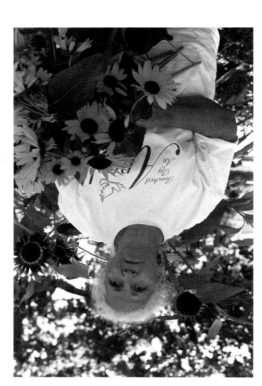

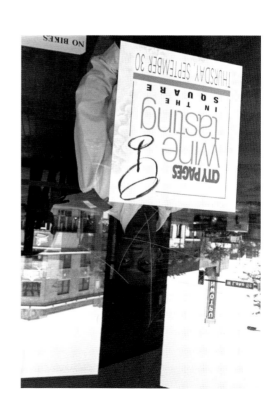

If you're a black man and you're younger than thirty, I wouldn't advise coming here. I'm from Jackson, Mississippi. I would like to be an officer of the law, but I wouldn't want to be one here. Officers are more prejudiced against the black Americans here.

We were getting off the bus from downtown on Thirty-second and First and there were two bike-patrol officers on the sidewalk. So me and my brother walked and talked to three guys standing there that we knew. The next thing I know, they had us all on the high country. Patted us down, just because we were a group of five black men standing on the street.

 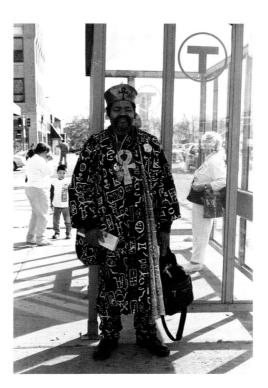 

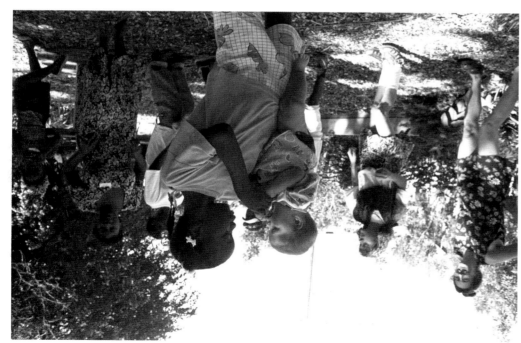

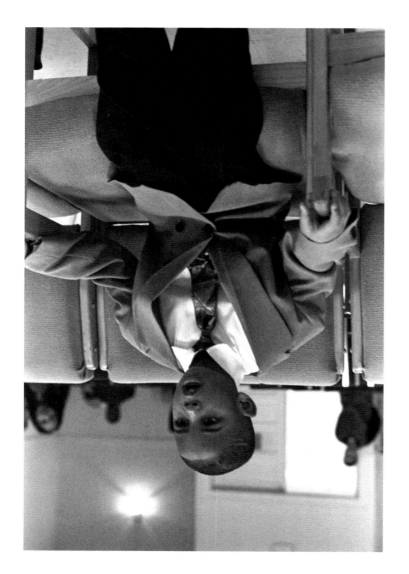

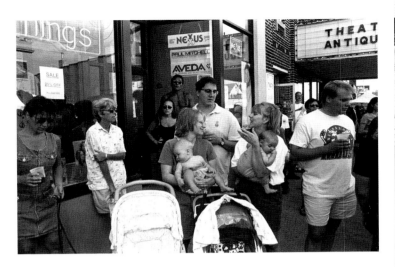

Some of us are runaways, some just want to travel. The world is our idiot box. But instead of watching it on some little screen, we sit out here and look at it.

We're homeless, but we work. Hitchhiking is work. Hopping trains is work. Panhandling is work. You have to go out and find food. It's stressful, but we choose to live this way.

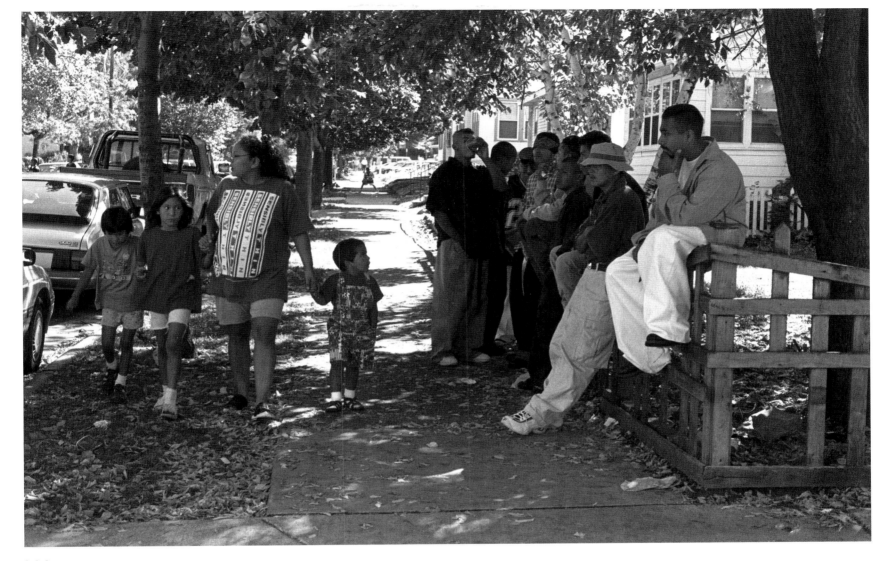

We call ourselves Vatos Locos. It means crazy boys. I be down for my 'hood. Don't let anybody disrespect you. If they do, then 187. You've got to stick together 'cuz there are other races that don't like Spanish, black, whites, or whatever. That's the only way we get some respect.

It's crazy fun, but sometimes it gets bad. Parties, girls all over. Bad part, sometimes people get shot. Drive-bys or just homicide. I'll be in it till I die or get too old for it. Like when I'm thirty.

A bris is a ritual circumcision where a Jewish male baby is welcomed into the Jewish community and given his Hebrew name. In years past, it was the father who actually did it, but now there is a trained person, a mohel, who actually does the operation.

All Nations Indian Church is located in the heart of the Phillips neighborhood, which has the largest concentrated urban Indian community in America. There are a good five thousand American Indian people living mostly in Phillips. Our congregation serves all of the neighborhood but is mostly made up of Lakota, Dakota, Anashinabe, Ho-chunk, known as the Winnebagos, some of the Oklahoma tribes, Nebraska, and a few from Canada.

We embrace a lot of our tribal traditions. We honor the cross and we honor the pipe and we honor the eagle feather. We have a sweat-lodge ceremony at Lake Minnetonka where members of this church go. Sometimes it seems this whole world is a big mental institution and a treatment center. And all the rules, regulations, religions, and governments are people learning how to love.

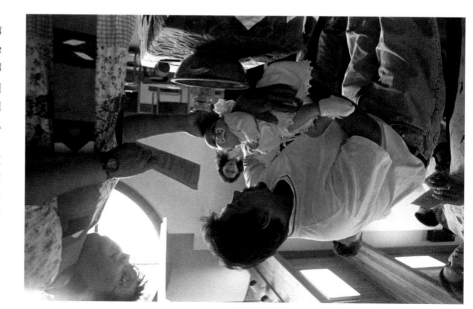

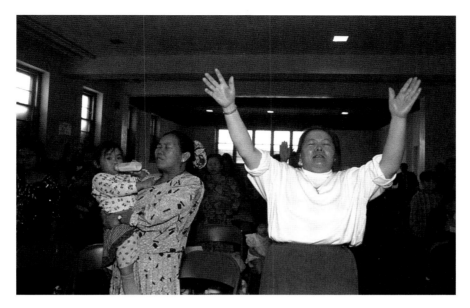

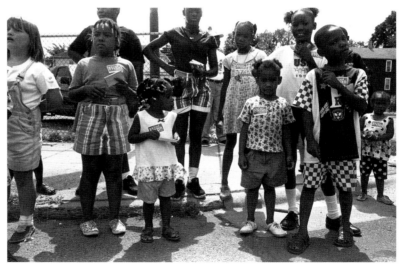

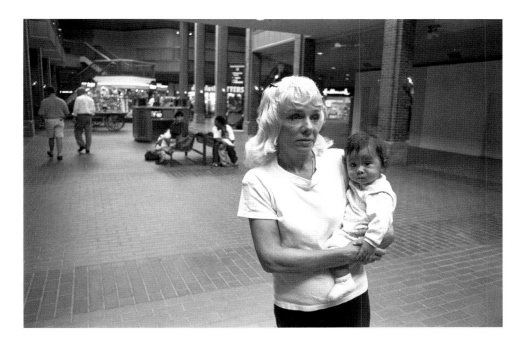

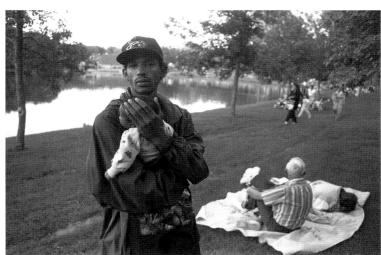

I'm the oldest woman in the state to give birth. I was fifty-three when he was born. Everybody thinks it's a grandchild. I'll be in my seventies when I'm going to high school graduation.

We're waiting for Papa who did not show up for visitation. We agreed to meet in a public place so he could see the baby. The baby is Indian, Thai, Lao, and French. And Mom is Polish. Doesn't he look Polish, which he obviously doesn't. We've lived in the neighborhood since 1964. I own my own home. I have five children. This is number five.

The father has a problem. He thinks everybody picks on him because he's not white. Like the police stop him because he's not white. He misses first place in a muscle contest because he's not white. It's a bunch of baloney. You don't see color after a while when you know people. Nobody sees color. I don't. Maybe people of color see color. I don't know. But he's a refugee. Maybe it's difficult to come from a different culture and run into prejudice as a child. He came when he was ten.

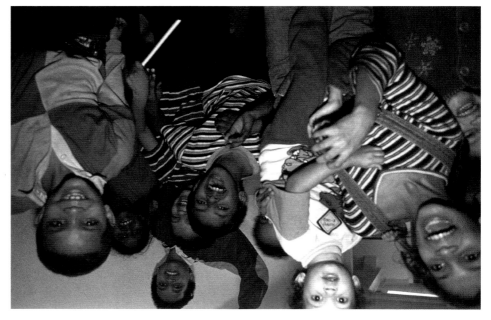

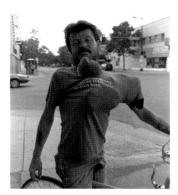

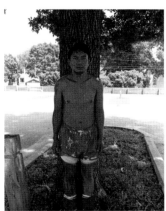

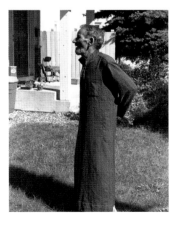

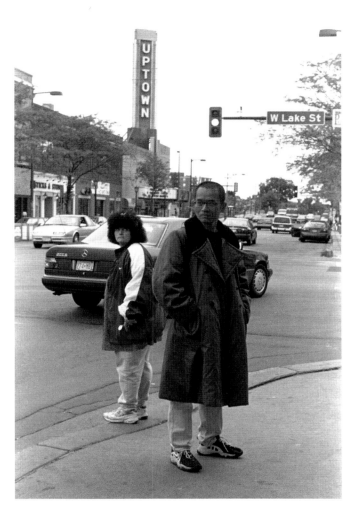

I was born in Shanghai. I went into the PLA [People's Liberation Army] during the Cultural Revolution. The government decided there were nine bad categories, and intellectuals was one of them. Because my parents were professors, they were sent to the countryside and considered antirevolutionary. So politically it made my family background better for me to be in the Communist army.

I hated the army. You had no freedom of thinking for yourself. We were at war with Vietnam. I had friends who lost their lives on the battlefield. I realized that the army was just a tool for politicians.

Now I am an artist. I still wear the army coat because it is a political symbol of cultural revolution and also American pop culture. Like Andy Warhol's paintings of Mao Tse-tung. In China, avant-garde artists wear the coat. It's black humor.

In Uptown there are a lot of arty-farty people. They are trying to find something exotic from mainstream culture. I like to walk to Uptown and wear the coat for high contrast. Even though I wear jeans and Nikes, the coat defines me as being from Red China.

One time I saw some demonstration in Uptown, and I thought that this would be a chance to let them see what the difference is. So I let people wear the coat that they might feel something special. So they can feel "I am a revolutionary!"

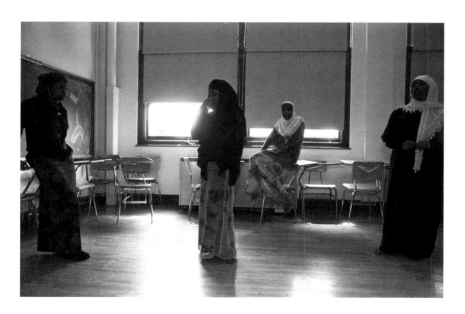

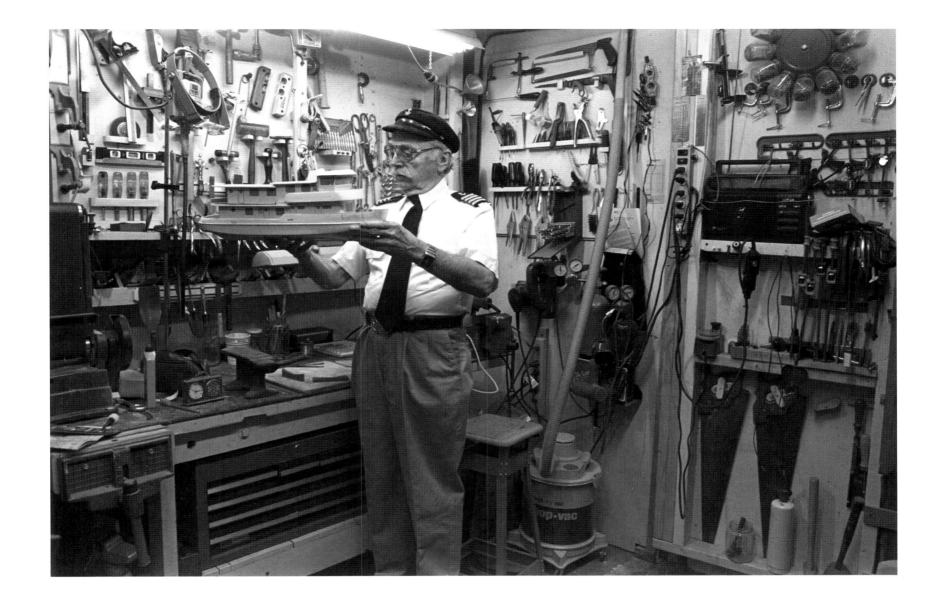

Minneapolis is a beautiful city, but the housing is all messed up. The city is quick to board houses up instead of putting them back on the market for the people who really need them. One of my goals is to rehab houses and help the homeless. It's a shame to see homeless people. Everybody needs a helping hand time to time.

So much of my life I took things. Now I'm trying to give back. I used to sell drugs and all that, you know. In a sense I was destructive to the community. Destructive to myself and to others. By me selling out there, in a way, that's how a person ends up being homeless. Now I'm trying to change all that.

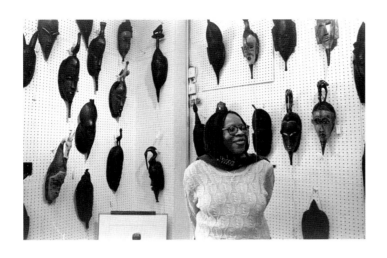

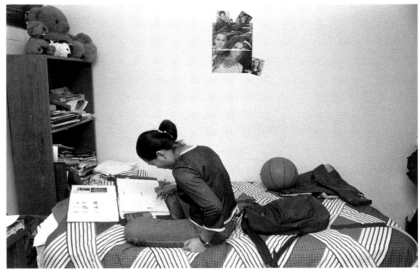

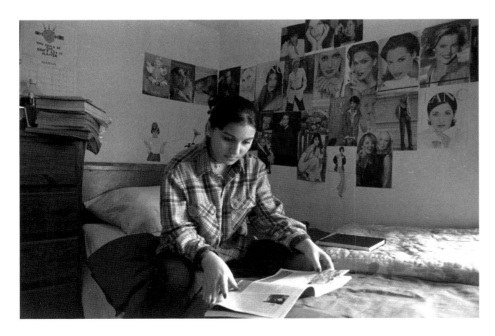

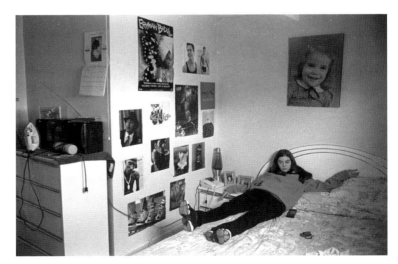

We're from Cameroon. This record shop is my hobby. My full-time job is working as a consultant for American Express. I hope to see our son get two real educated. I have three degrees and educated. I hope he can beat that. I hope too that he will be able to apply his education. I don't want to see him selling in a record shop. I want something more meaningful for him.

I worry about the crime and drugs in this country. I'm not saying that this is a crime-ridden country, but it is high. The people in my country are poor, but they don't prey on each other like they do here. I saw some kid get shot right out here while I was talking to somebody.

It's quite a challenge raising him because when he goes to school or day care he's got few chances of meeting African children, let alone children from Cameroon. So what we do is make sure we instill in him some of our Cameroonian values. The most important thing is respect, especially for older people. For example, my mother lives with us. So when our son comes home, the first thing he needs to do is to go downstairs and spend time with my mother. It's a lot of fun seeing him kick my mother's door open, pop in, and talk.

We are also teaching him our native languages. Cameroon has seventy-two native languages. French and English are the official languages, just like Canada. I don't expect him to speak all seventy-two, but he's got to speak his mother's language and the language of my mother and father. Also some French and, of course, English. He's got a challenge being of Cameroonian heritage.

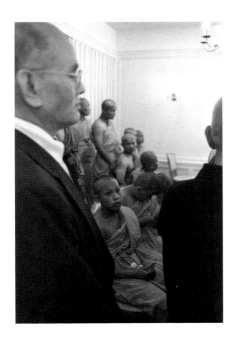

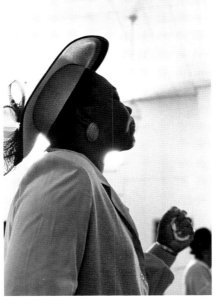

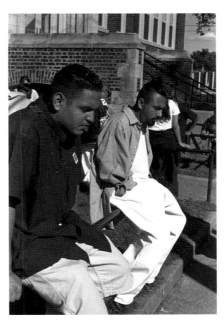

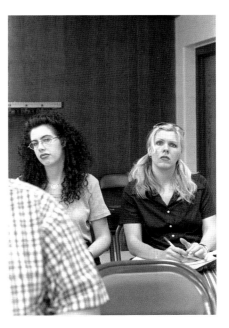

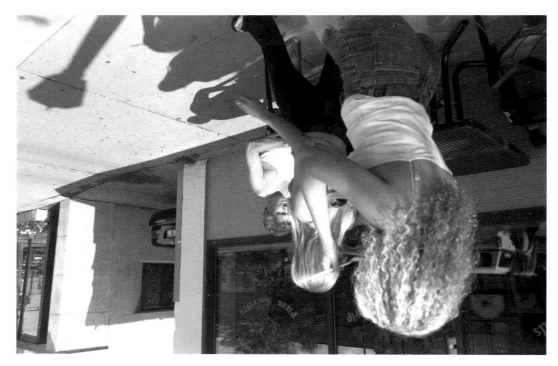

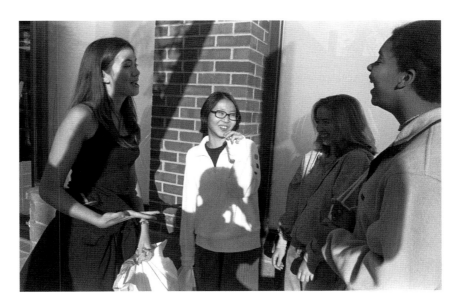

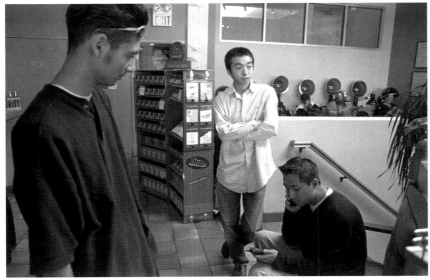

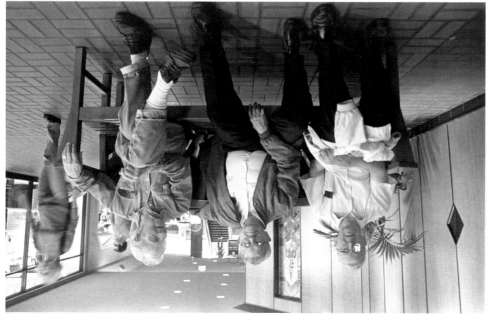

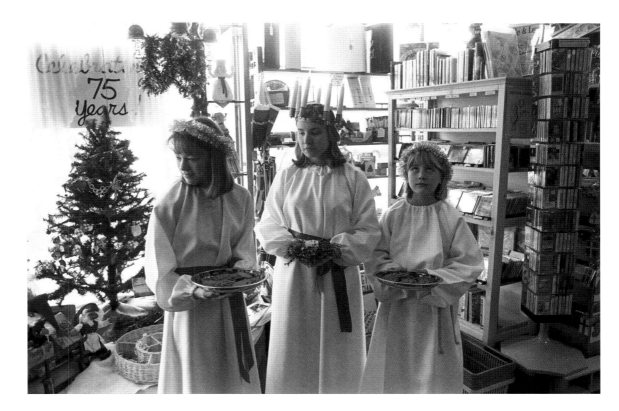

*For the traditional Swedish celebration of St. Lucia, the oldest daughter of the household wakes up very early on the thirteenth of December and puts on a white gown, red sash and crown of candles. She then wakes the rest of the family to sing carols and eat traditional food.*

This was my first time doing this. My older sister has done it for years and I thought it was neat that I got to do it. It was scary at first because I felt funny dressed up like that. But after you've been in it for a while, you don't think that you have it on.

Everybody at school thinks I look Swedish. We were making a float about Sweden and people kept coming up to me and saying, "You look so Swedish." And I just said, "Yeah, I'm Swedish." I think people think that all Swedes have blond hair and they dress up in costumes. People think I have an accent like a Swedish person. I don't think so at all. I don't know why they think that.

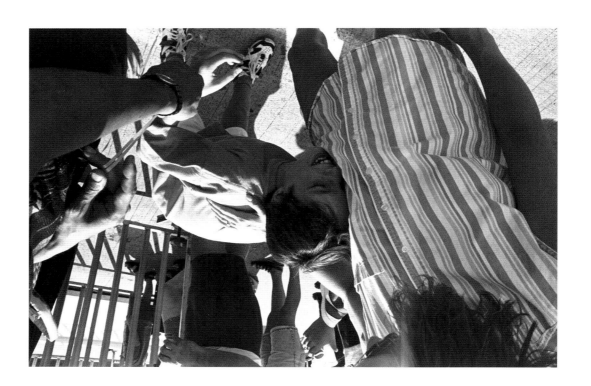

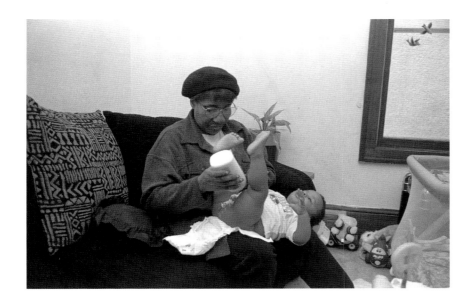

I have eleven children, sixty-nine grandchildren, and seventeen great grand. I've also raised three foster children who are relatives. Even at my age, because of my love for children, I'm still ready to take on a couple of more.

I have the good, the bad, and the ugly. It doesn't stop me from loving them. I tell them right from wrong. If they listen, it's fine. If they don't listen, they just have to move on. I just don't condone any unnecessary problems anymore. They move on.

*One of her sons has been in and out of jail most of his adult life. His frequent arrests have made him the local precinct's most "active and detrimental" repeat offender, a title based on his number of arrests for violent crimes, narcotics, felonies, misdemeanors, and outstanding warrants. Often he would leave gifts in her back doorway. Things he found in Dumpsters that he fixed. He was always creative, she says, but he did poorly in school. It wasn't until later that they realized he was dyslexic. By then he was already getting into trouble. He was in jail again when this interview took place.*

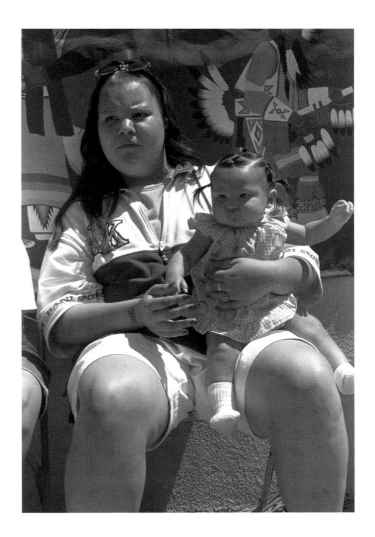

W e have a healing ceremony. Most don't actually touch, but some do. You say a prayer and ask to be used as a channel for healing. The energy comes in, flows through you, and goes to your client. All healing comes from within themselves. What this does is removes any energy blocks in the body so that they can heal themselves.

We all get energy blocks, stale energy, old energy, stuff we're holding on to that has to be cleared out from time to time. By running the energy through, you clear all that out and keep yourself from getting ill. It works on anything. If the energy was perfect all the time, you would never get sick. It's at all levels: mental, physical, spiritual. Christ did these things and said that anybody could do it. We just carry on in that tradition.

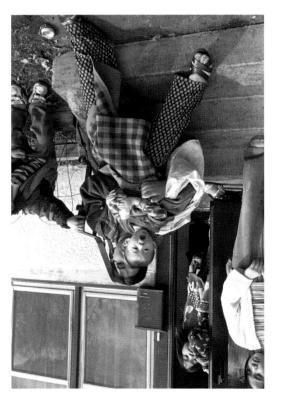

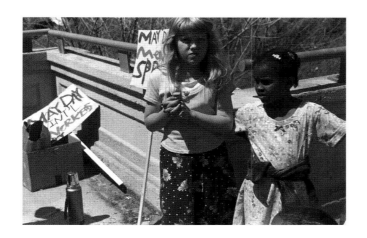

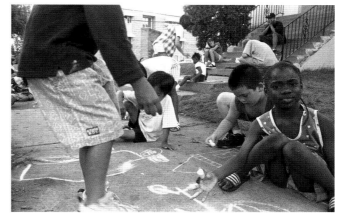

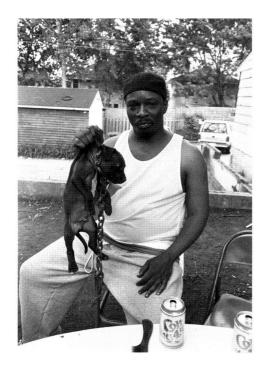

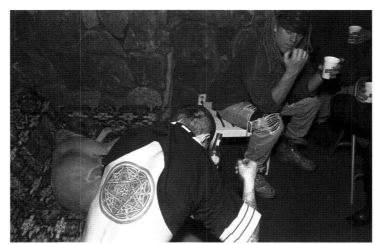

I have three names. I use the name Mark De Bauch for my erotic work. It comes from the word *debauch*, which means perversion or to corrupt. I use my legal name for my conservative landscapes. Satyarthi is the name I received twenty years ago from my spiritual teacher in India, which means seeker of truth. I use that for my spiritual and mystical work.

I'm a chameleon. I try to fit into different parts of society with my art. But some of my work isn't accepted by most of society. They think some of it is pornographic and that by putting it in magazines I'm prostituting myself. For me, prostituting myself would be working at Burger King. I don't paint ducks. I don't paint deer. I'd like to make erotic art as available as wildlife art or religious paintings.

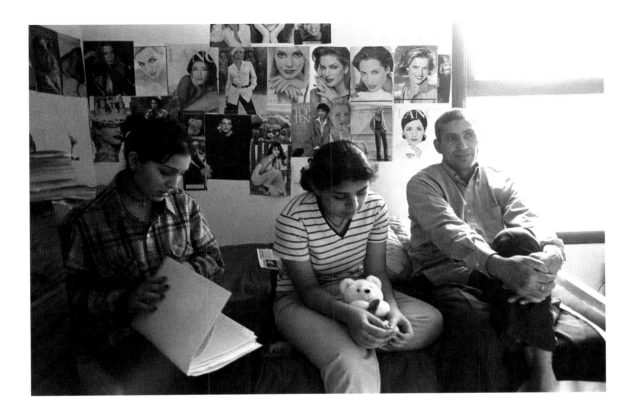

Back in Egypt, Father was a teacher. He taught geography, science, and math. He also worked in a chemistry lab. Right now, he's a dishwasher at the Hyatt. He's learning English at the Lehman Center. He hopes someday to teach, like he did in Egypt.

Our father is very religious. He prays five times a day. I think he's even more religious after we came here because he's afraid that we will forget about our language, culture, and traditions. But it's hard for us because he wants us to cover our heads. It's the Muslim tradition.

He wants us to cover most of our body and not wear pants. We have a lot of arguments about it.

In Egypt we had to wear scarves and long dresses. We don't wear them now because we are in America. Everyone can wear whatever they want. I think that's good. I want to be different and have my own way of life. I'm not very religious. I don't pray. I do a lot of activities in school. I like learning. I'm on the National Honor Society. I want to be a heart surgeon. I want to be famous.

T he Spirit of the Lakes United Church of Christ is the first openly predominately gay, lesbian, bisexual, and transgender [GLBT] congregation within a mainline denomination, as far as we know, in the world. The Christian church historically has been incredibly heterosexual and homophobic. So for many folks, they have had to choose between their sexuality and spirituality, or they remain completely closeted. The language of religion is often the language used to oppress GLBT folk.

We're just starting to see the results of the Stonewall Riots. This church is part of that whole struggle. Every year there are more open and affirming churches that welcome GLBT folk. The word is out about Minnesota as a GLBT mecca in the Midwest. There is a level of acceptance here that you just don't find in many cities.

One of our primary focuses is to be involved in the neighborhood. Homophobia is just one expression of what creates an unjust society. I don't think it's an accident that we ended up in the Phillips neighborhood. Just five years ago we were Murderapolis, and now Phillips is a port of entry for many immigrants and one of the more exciting neighborhoods in the city.

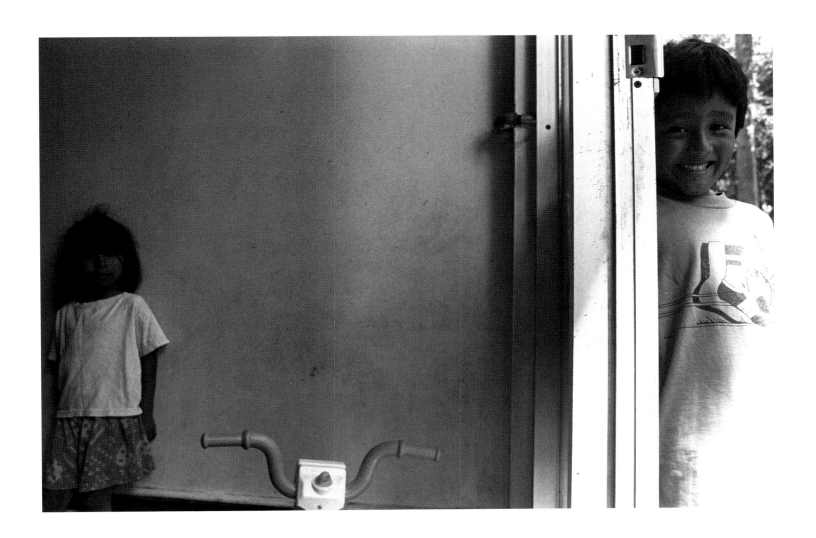

I've had a pretty privileged "white" life. What I mean by that is that I can be in an elevator with a group of white people and they're making remarks about black people and "others" not realizing I'm the "other" they're referring to. The irony of it is that the little discrimination that I've had is when people think that I'm Jewish or Native American.

I'm Lebanese American. Being Arab isn't a race necessarily. It's not really a religion. I read in a book that the only thing that defines Arabs is the Arabic language. Like Asians, outsiders sort of lump us all together. In reality it covers a variety of looks and backgrounds.

One of the things we do when we get together is make stuffed grape leaves, which is a traditional Lebanese and Mediterranean food. In the past almost every Arabic household would have a grapevine growing. But now a lot of us live in apartments, so we've developed this little network where grapevines can be found. Most Americans don't even realize you can eat the leaves. Grape leaves grow wild everywhere. A lot of cemeteries have them growing along the fences.

In my family, the cooking was done by my dad's mother. But she was very, very secretive of her recipes. She wouldn't pass them on to my mother, who was white. So my mother would peek over her shoulder and make little notes. Ironically, it was my mother who saved part of our Arab culture by writing the recipes down.

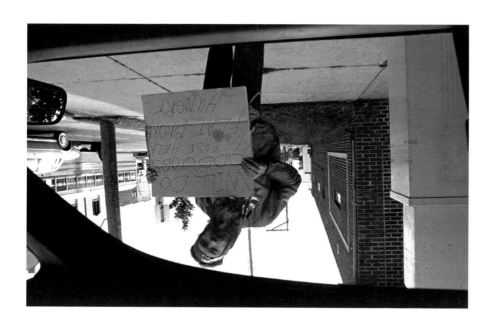

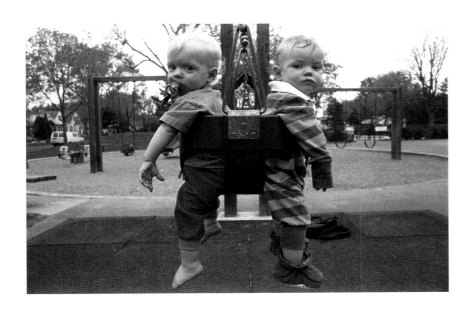

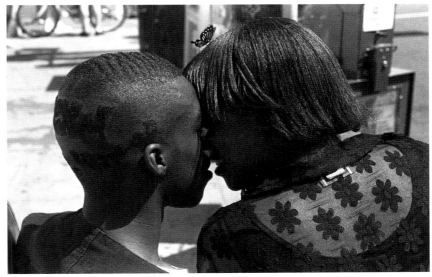

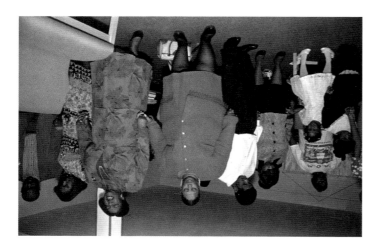
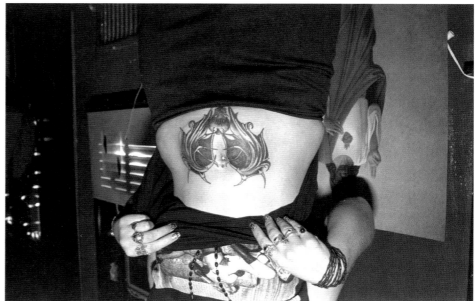
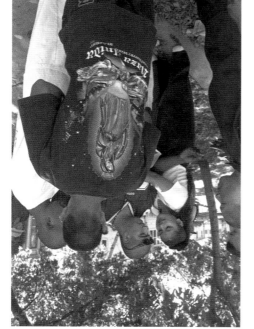

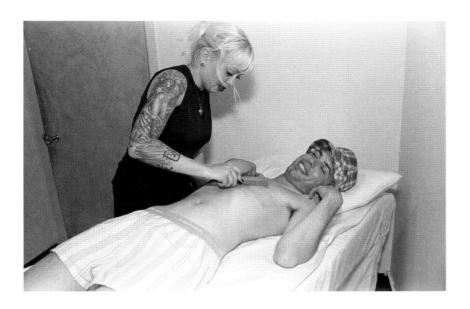

I love to get my stomach and chest waxed. It makes me laugh. I like the feeling of smoothness against my clothes and raw skin. I just don't like hair. I like to be smooth.

The pain almost feels good in a way. It's like a sexual experience. You want it to happen and you don't want it to happen. It's kind of weird. It's like nothing I've ever felt before. One moment it can hurt, and the next moment it can make you laugh.

It's also kind of appetizing to the mind to see all the hair removed. Like when you play Pac-Man. You want to get rid of all the little dots. And you can't stop. Then it kills you.

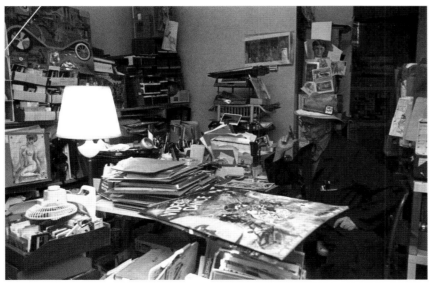

When I was three years old, I surprised everybody in the family. I drew a train. Everybody's eyes and mouths popped open. They were running around holding this picture as though they had found the goose that laid the golden egg. Then my older brother started pounding my head into the ground. Sibling rivalry, you see.

So help me Hannah, I've been struck with the idea of drawing ever since. Instead of just dreaming or wishing for something, I put it down graphically. That covers all sorts of fantasies that anybody has. I've tried everything. Calligraphy, animation, billboard design, fine art, eroticism, advertising. But I'm still searching for that one thing I can focus on. I still have some unfulfilled desires.

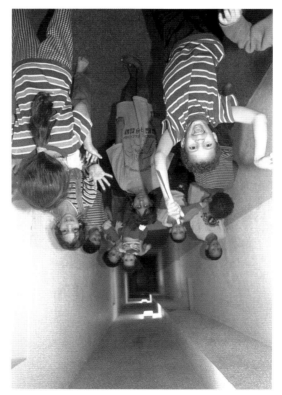

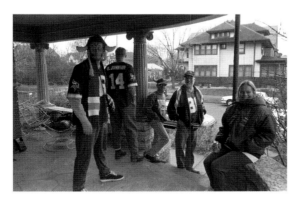

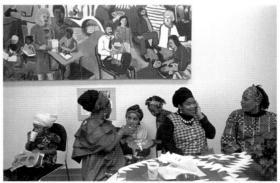

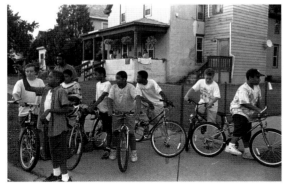

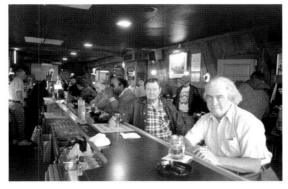

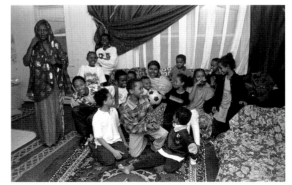

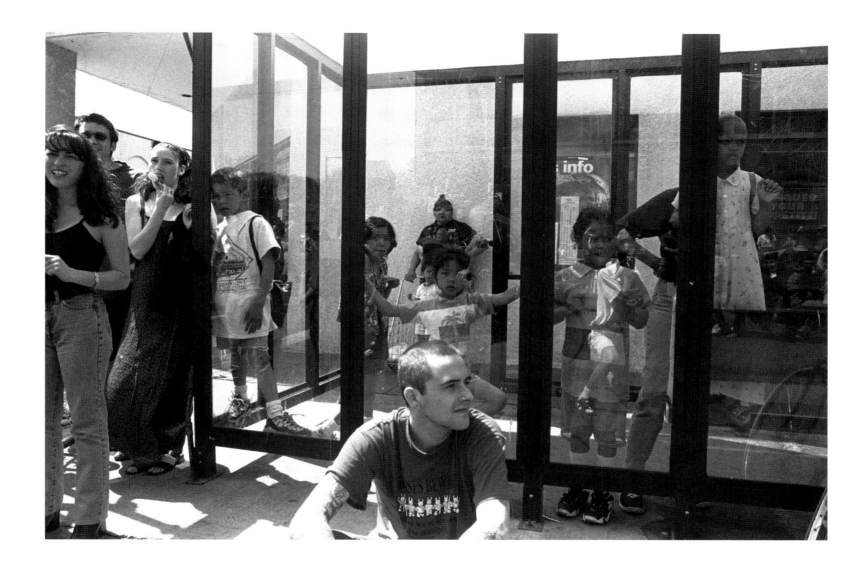

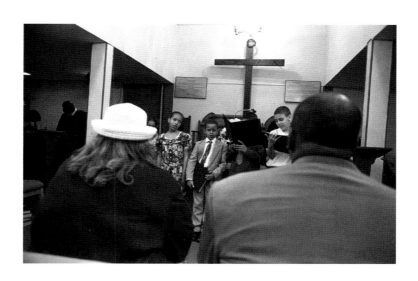

A young man was threatening somebody with a gun and so these children were ushered into the basement of their apartment building for safety. One of the parents said that it is a regular occurrence.

Everyone enjoys the gorilla. The gorilla is the common denominator of the anthropoid species. A figure who binds all of humanity. Sometimes I think people like seeing the gorilla more than the clown. I find a certain integrity in the knowledge that if I did this forty hours a week I would make about forty grand a year. Would I like to be a gorilla forty hours a week? Sure, for forty grand.

Usually everyone who hears the word *metal* thinks of Satan right away. They start tripping out. My mom thinks I'm worshiping the devil. I tell her that just because I listen to something doesn't mean I do it. I was born to be a Christian, but I really don't believe in any-thing. I'm a Christian with satanic vibes, just put it that way. I just can't stand the idea that you have to love everyone. It's retarded. I mean, how can you love someone you don't even know? I just hate the typicalness that certain people have. I just can't stand it.

I like really rare black or death metal. We're from the 'burbs. We come here because we can't get this shit anywhere else. They have pretty much everything I want. Bands like Cradle of Filth, Dissection, In Flames, and Virgin, which is the German word for darkness. I really don't know why I like it. The first time I heard it I thought it was really powerful, not like the pussy stuff you hear on the radio, like Mariah Carey.

Día de los Muertos or Day of the Dead is a way of celebrating people who have died. We believe that spirits come back to visit their relatives and so we must prepare a feast for them. In the home, a family will prepare an extra plate for the person they're honoring. They'll leave the chair empty. In Mexico it's celebrated in different ways. Sometimes people will spend the whole night in the cemetery. Looking at death is a way of affirming how important life is.

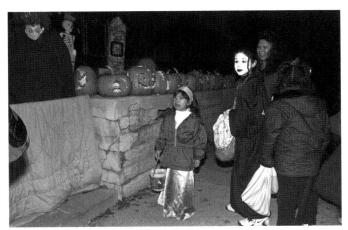

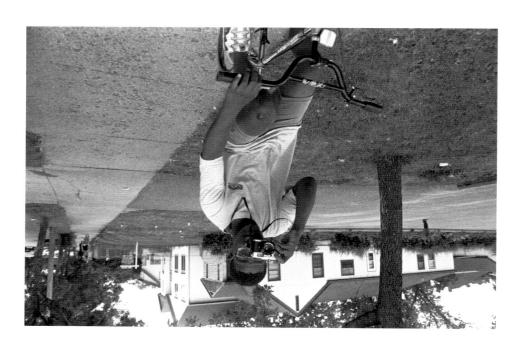

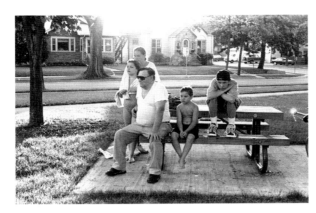

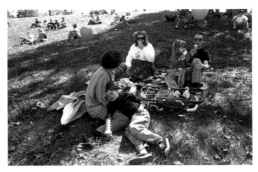

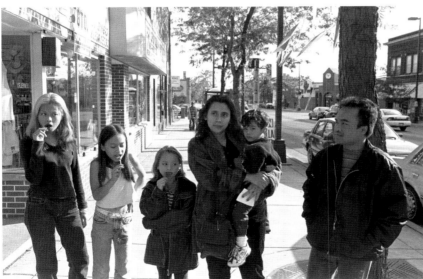

I was born in Minneapolis. My husband was born in Laos. We met through a mutual friend. I'm a Chicana. My great-great-grandparents are from Finland. My dad is Mexican.

We live in Savage, but we come in twice a week to go shopping on Nicollet. We both have family here. We shop in the Asian stores because the American stores where we live don't have all the things we need. Rice, fish sauce, noodles, and stuff.

I've been coming to the Vend-a-Wash since September 1960. We moved here from Las Vegas where I was stationed in the Air Force. My wife and me picked Minneapolis because we thought there would be less crime. This was the first Laundromat that we came to. Even when we got our machine, I would come down here and press my clothes. Now I live ten miles from here, but I still come down.

I don't have any complaints, to tell you the truth. I worked for the housing authority for twenty-seven years. The only complaint I have now is how we treat each other. I don't understand why we have to treat people bad.

I wrote a book about my life called *No Time to Cry*. It's about a young black born in 1926 in Clifton, Tennessee. I never had a father. My mother was fifteen when I was born. My grandmother and an aunt helped raise me. We stuck together as a family unit, no matter what. My grandfather killed a man somewhere around 1905, so he was not around as a male protector. Later he killed seven more people. He spent most of his young life in jail. He's the one made this neck-lace. His mother was Cherokee. He made these when he was in the penitentiary.

I was one of the youngest military survivors of Pearl Harbor. At age fifteen, I was on the USS *Vega* on December 7, 1941. At the time, I thought I was going to hell for all my wrongdoing. At the end of the war, I received two silver stars, two oak-leaf clusters, nine ribbons, and one bronze star. I hope you will be interested in my book. It's a true story.

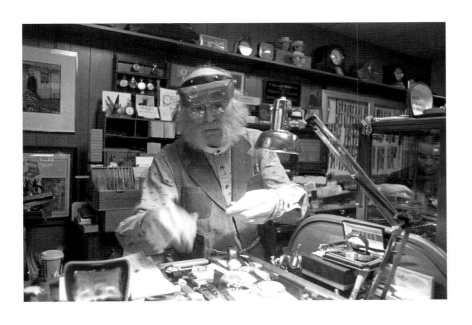

Haud means jungle. We cook Somalian food [at Haud Coffee]. Rice, spaghetti, goat meat. Somalia was colonized by Italians. That's why we eat spaghetti. It's a social place mostly for men. When they have nowhere to go, they can sit here and talk to each other, yell, and do whatever they want to do. In the cafés in Somalia, it's the same. One hundred percent men. The women gather at home. That's our culture.

We talk about Somali politics. They get advice on how to get a job, driver's license, green card, an apartment. Sometimes they don't have money so we give them food. Everybody has to eat. We teach them English or tell them about American behavior. We tell them that you don't have to yell to each other when you're in a public place or café. Somalis are loud. That's normal for them. We're a nomadic people. In Somalia there are wide-open spaces. When you call for someone, nobody hears you unless you yell.

Many Somali people work two jobs. But for them, it is easy. Anybody who has worked with a camel works twenty-four hours a day. Sometimes with a camel you don't see a city or water for three or four days. So Somali people say working sixteen hours in America is nothing.

We're a very tight-knit, funky urban family. Free spirited. Tolerant. Fast paced. We have distinctive, urban type of personalities, just like the city where you have pockets of uniqueness.

We live in Linden Hills. By living here we are taking a stand, supporting all the cultural and environmental diversity. It's not homogeneous or monotonous like the suburbs. My wife, Abra, defines funkiness. She's very progressive, very hip. She's the mother of the new millennium.

*Abra:* Weekday mornings I get up at 6:45, get them out of bed, come down for breakfast, and argue about who's going to eat and who's not going to eat. Then I get them out the door, which can be really intense. My husband comes down and has green tea and then runs to catch his bus, holding his green tea. I go to work, he goes to work, and then we come home and do it all over again.

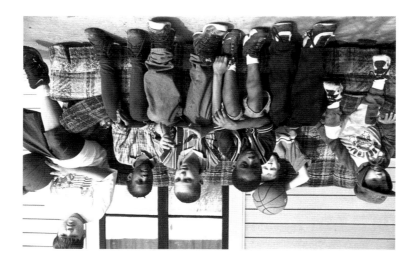

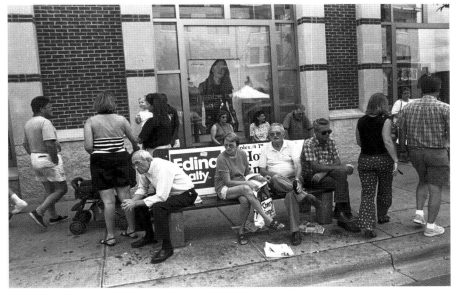

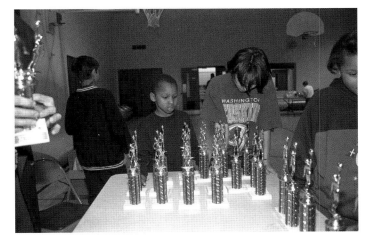

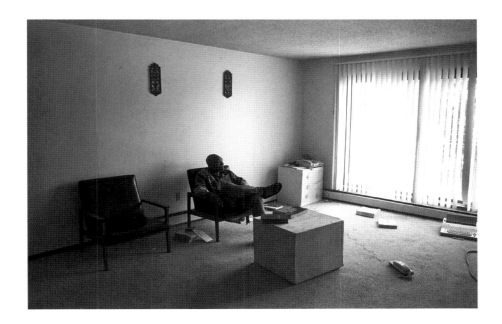

I was born in Aba, Nigeria. One day when I was sixteen, I went with my sister to the post office where she worked. She was sorting the mail, and I saw the name Concordia College, Moorhead, Minnesota, on an envelope. So I copied the address. I was a little ambitious. I didn't have any idea about America. I wrote to the school and they gave me admission.

I went to Concordia and got my four-year degree in economics. After that I came to Minneapolis and got a master's in natural resources management. Now I work as a skycap at the airport.

I believe if I had stayed in Africa I would have been more of a symbol than I am now. Here I am nothing. I don't have status. Just an educated man. Black African man. An American man.

Many of us came as refugees when we were driven out of our home country during the Second World War. In 1941 the Soviet Union conducted a mass deportation of the Baltic people of Estonia, Lithuania, and Latvia. Our service is in Latvian. We wanted to stay with our traditional language because if we dilute it by bringing in English then eventually the Latvian will disappear. We do not have many young people in our congregation. Assimilation into the general society is the primary reason. But we do have some families that maintain our traditions and language by sending their children to special Latvian summer schools. We call them Super Latvians.

In some ways, we have made our church into a fortress. Most of our people are from outside of the area this building is in. We don't even know who our closest neighbors are. But it is our particular lot to administer only to Latvians. We try to do the best we can.

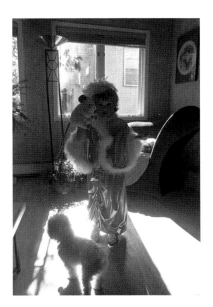

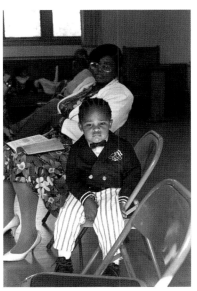

I've seen her in the dead of winter carrying cans balanced on a pole like the way she carried back food from the market in her native Cambodia. She does it for the money ($16 on a good day) and because it gives her a purpose every week. But it's hard work and her legs are bruised from the rocks kids throw at her.

She never gets sick, says her daughter, even though she eats very little. After I took this photo she sat under the shade of a bush in the McDonald's parking lot and pulled out her lunch, a small plastic baggie containing some green leaves. Later, when I showed her the photos she shook her head, kind of laughed, and said, "Too thin. I used to be much prettier."

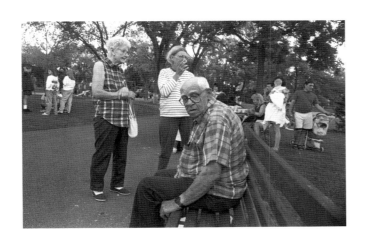

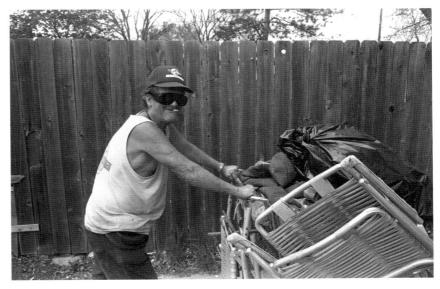

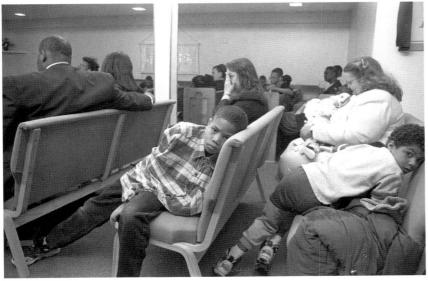

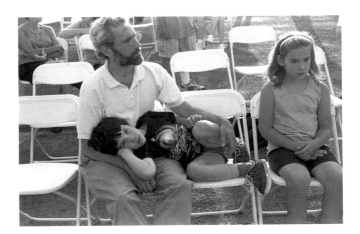

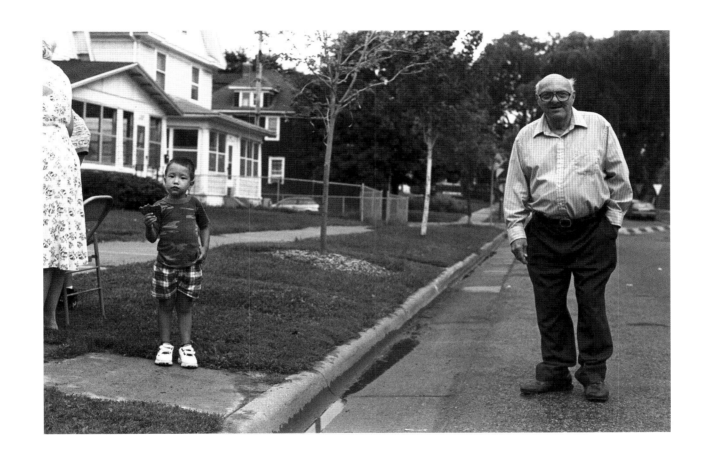

W e are an interdenominational Christian church. Our congregation is mostly from Liberia, which is on the west coast of Africa. It was founded by the descendants of the free slaves who went to Africa and decided to seek a new life. The first group arrived in 1822.

Our culture is 95 percent similar to that of the United States. We identify more with America than any other international community. More, unfortunately, than even some of our own African brothers. That happens.

There are roughly twenty thousand Liberians in Minnesota. Although some have been here for more than twenty years and are established, most have come in the last five years. Most came as a result of the civil war in Liberia. And more are coming on a weekly basis from refugee camps.

Minneapolis/Saint Paul is a central place for Liberians to come. Rhode Island is the only state that has more. There are a lot of good things about this place. Housing facilities are good. The social life is good. The economic life is good. The only complaint I hear is the cold.

We have friends who are moving here from other states because friends are telling them, "This is the place. Come on down."

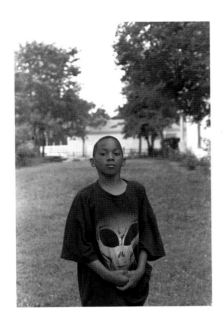

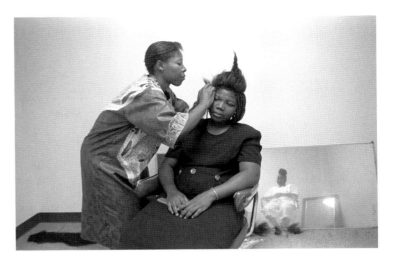

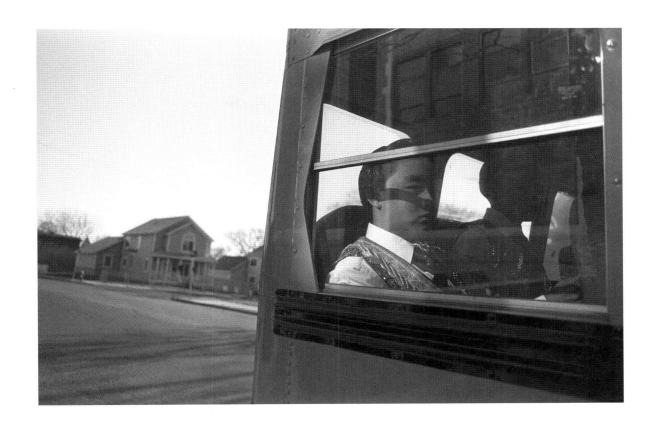

Ingebretsen's is a Scandinavian gift shop and deli that's been on the corner of Sixteenth and Lake since 1921. Many of our customers are people who grew up in this neighborhood and have since moved out to the suburbs. We're a link to what Lake Street used to be and what it is now. It's important to me because it brings people back into the neighborhood who wouldn't normally come here.

There are people who live in the outer suburbs who will not come here. They call us up and have stuff shipped to them. It's sad. It doesn't have to be that way. A lot of it has to do with the way people look around here. This place looks different than Edina or West Bloomington or someplace like that. People are afraid of difference.

There's a perception of danger on Lake Street that is way overblown. Yes, bad things happen here as they do anywhere. We tend to be a scapegoat for the inner city as a whole. I think that the media plays upon that perception, but when similar things happen in other places, they play it down. The reality is that I've worked here for twenty-four years, and I've never had anything bad happen to me.

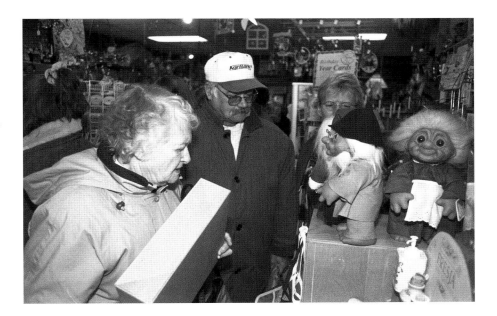

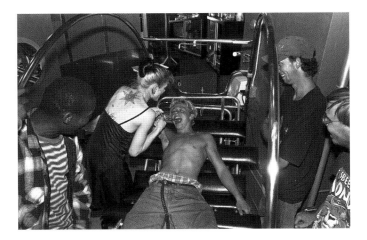

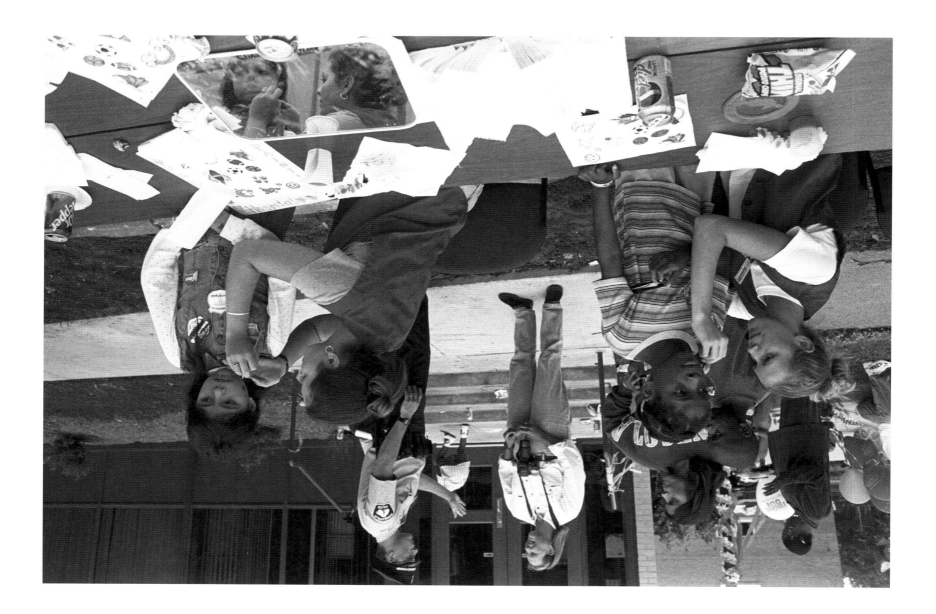

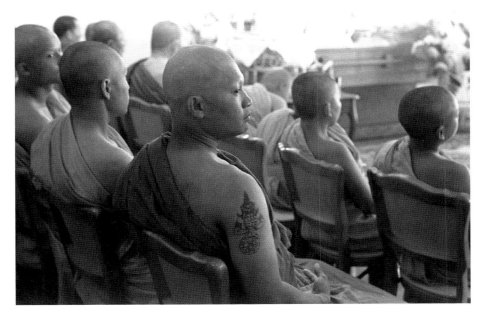

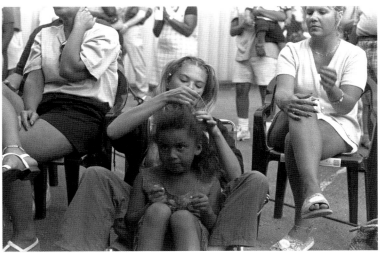

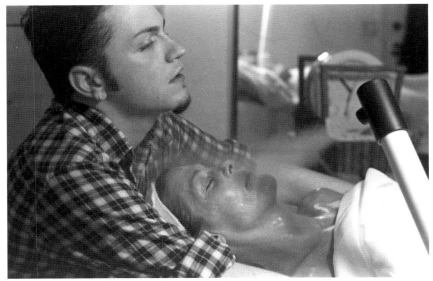

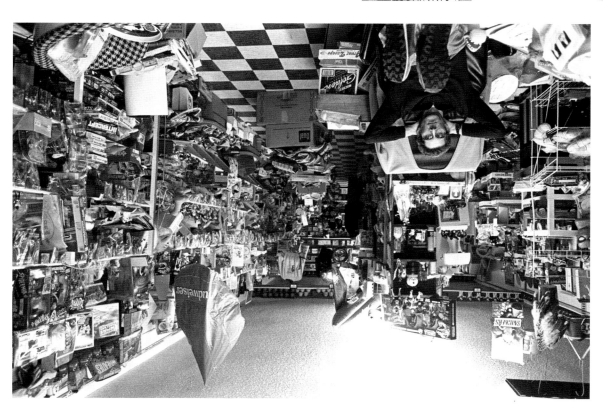

The name of my store is 15 Minutes, taken from Andy Warhol. I'm surrounded by stuff that I like to deal with. Cartoon characters, TV characters, famous movie stars, anything that was hokey and schlocky and of limited time value.

I like preserving the not-so-distant past. It's stuff you remember from yesterday, but just barely. It's in and out so fast that I like to grab ahold of it and sort of put it in a museum. Lunch boxes with Star Wars, G.I. Joe, and Barbie dolls, Simpsons, Garfield, Peanuts, Dr. Seuss, Playmobile, old Fisher-Price, Lincoln Logs, Etch A Sketch, yo-yos, Bugs Bunny, the Jetsons, Strawberry Shortcake, Smurfs, He-Man, and the list goes on.

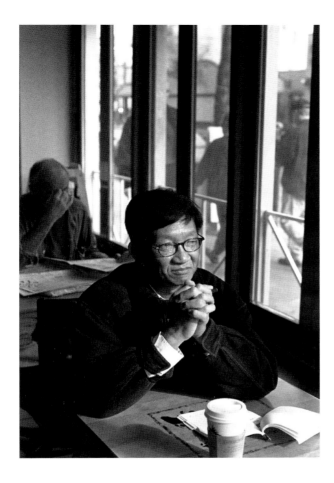

This corner has always affected me. For some reason, I just like to sit here and drink coffee and look out at the people walking by. The people who come to this area seem to come from different backgrounds. But they all look happy.

I come two or three times a week. Sometimes on weekends, I come two or three times a day. I live in Apple Valley, about twenty miles away. If I don't have a chance to come then I feel stress. There's no other place in this city that has the same feeling for me. I can sit here and not even realize I'm sitting here. Sometimes I immerse myself into my cup. I write a lot of my poems here. I don't write about this corner. I write about feelings. When I have pain, I have to write. After I write, I have more pain. I feel better for a short time. Then I feel more pain.

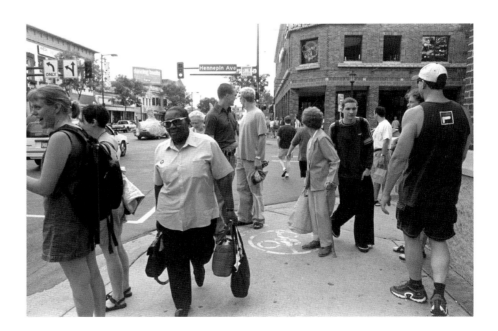

We're a spiritualist church. We take from the teachings of Christ, but we also channel personal messages from friends and relatives that are deceased. A lot of people are afraid to talk to the other side. But my gosh, if your aunt was good to you when she were alive, why wouldn't she be good to you in spirit?

I've heard voices all my life, I just didn't know what they were. One Sunday it just happened, I started to do it. Clairvoyance, intuition, trances, psychics—it's all the same. We just want to give happiness to people by making it possible to talk to loved ones. It's proof that this life is not the end.

Sometimes Mother Mary will come through me and give a blessing to the people. I also do automatic writing. That's when someone will speak through me and my hand will start writing. One time Ernest Hemingway wanted me to write for him. He wanted me to write another book for him, but I just didn't have the time.

My son was seventeen when he killed himself. My other kids haven't accepted it. They keep saying other people killed him. When he was younger, he had a problem of being real active. And by me being so young with five children, I couldn't show all my love and attention to just one child that was just so active. What he wanted was a father figure, and there was no father figure in my house. So I reached out and got help from the government to put him in a children's home for boys. He was eight years old.

He did real good. Straight As and Bs. When he was fourteen it came time for him to come home. But he hooked up with the wrong crowd, the young boys with the pants sagging and the gang banging. I didn't allow that, so I fussed at him to get on the right track. He had a real anger problem.

The night it happened, he had this horrible temper on him that was so bad. He was being so angry and mean. He said to me, "You kept my sisters and brothers, so why couldn't you keep me?" I told him why I couldn't keep him. . . . It's good for me to cry. I cry for joy because the anger that was in him can't hurt him anymore. He's in a better place.

He's still here kicking it with us. I take him anywhere and everywhere. Grocery stores, movies, to the mall, downtown. When my nephew got his first car, he put him right there in the front seat. My daughter asked to take him to school. Sometimes he spends the night at my sister's house. She sits him at the dinner table with her and her husband. They'll talk with him like he's really there. He might not be picking up that spoon and fork, but he's still here with us.

*This was a memorial service for Lillian (Tiger) Enrooth, an eighty-three-year-old lifelong resident of the Longfellow neighborhood. Officers found her body in her home, an apparent victim of a random killing.*

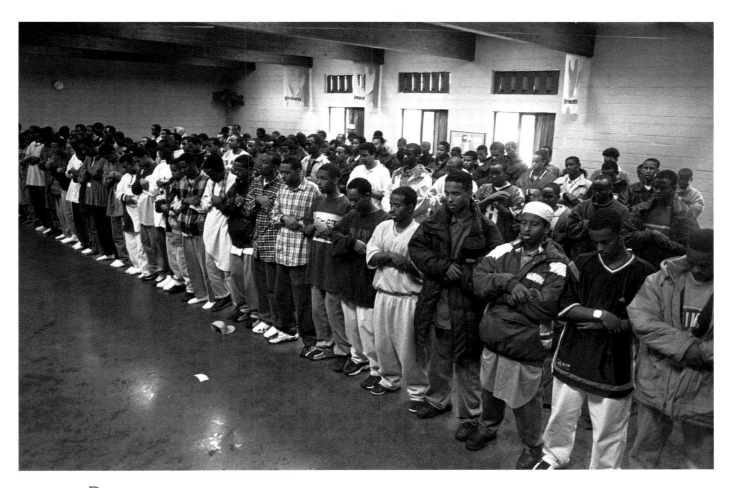

Because of the separation of church and state, these Roosevelt High School Somalian students pray as a group across the street at Our Redeemer Lutheran Church. All are devout Muslims who pray five times a day.

Half of the estimated thirty thousand Somalians who have emigrated to the United States since the early 1990s have settled in Minnesota. A quarter of the student population at Roosevelt is Somalian.

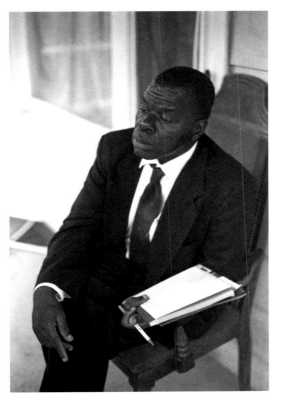 

I try to sell vehicles to people who are a little bit destitute, a little bit down and out. People can go up and down this avenue and buy a car in nine different lots, all within fifteen, eighteen blocks. So we'd like to have them come here and stay with us and buy other cars in a low-key-type atmosphere. We've been pretty successful with that.

The cars are sold as is. Sometimes they call and have a little complaint and need some help. If it's legitimate, we try to help a little bit. Of course, we can't give away all the money. But we try to be humane about it.

We have a lot of repeat customers. People feel comfortable here. They know they are not going to get lied to. They call me Pops. One of my customers gave me that. I guess it was kind of a bonding thing, I'm like a neighbor. I'm in the heart of the community.

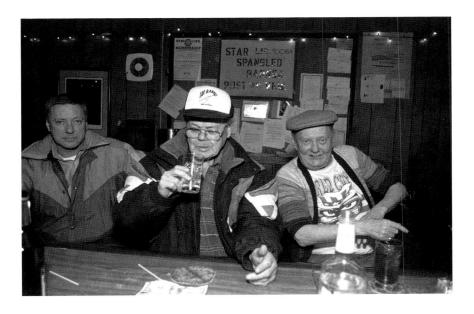

I served in Korea. I started coming here in 1952. I live two blocks away. We're all veterans here. It's my only home. I come here five days a week. I need two off to get away from these guys. My kids are all grown up and my wife is dead. We sit and talk, drink, and play pool.

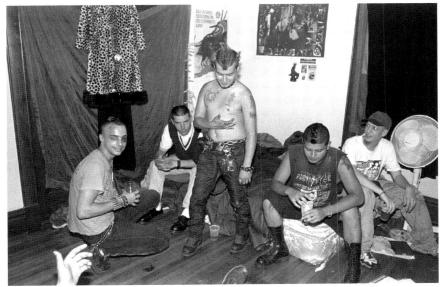

We're great guys. We're nice people. I like to do things everyone else likes to do. Go to bars, shoot pool. Work. But people look at us with their noses stuck up in the air automatically. So we come off as aggressive, scary, or gruesome just to screw with them. Just to make them mad. Some people say, "What's wrong with you?" and we say, "Satan possessed our hair." We don't believe in shit. Our god is fear, and we go to a place called a bar to worship.

What do we believe in? Just fucking have fun. Get as much shock value as you can. Listen to good punk-rock music. Fucking drink a lot of beer.

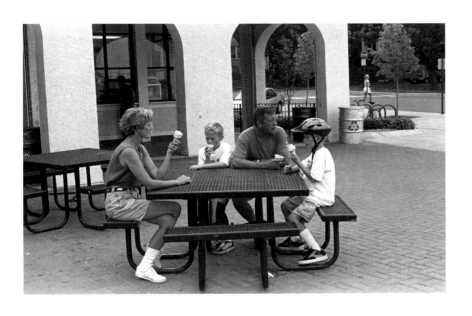

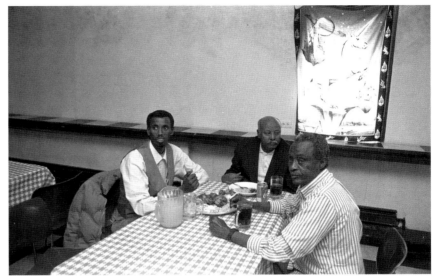

The Jewish holiday Sukkoth is a harvest festival that commemorates the period after the exodus from Egypt during which the Jews wandered in the wilderness and lived in huts. We build a sukkah every year in the backyard out of cornstalks and tree trimmings. It lasts eight days, and we generally eat as a family out there every day.

One of the urban legends is that about ten years ago a young Jewish family in Powderhorn was sitting around in their sukkah after dinner, singing songs with their kids, having a great time, and the cops came and busted them. Because the neighbors had heard people chanting in a strange language in this backyard hut, they thought this obviously was a satanic ritual and called the police.

It's funny how my appearance affects people. For instance, the kids in the neighborhood think this is a witch's house. Some of them were in the backyard when I opened up the back door and they screamed, "We saw the witch! We saw the witch!"

The way I am evokes fear and discrimination, even the threat of violence. I want to demonstrate that each person needs to deconstruct the givens in order to discover new possibilities for life. When this happens, fear and intolerance fade.

*Steve:* I didn't feel male. My body was male. I have worked for a long part of my life to try to be as male as possible. Cutting my hair, growing a beard, wearing bib overalls. I explored as much masculinity as I could.

I almost feel like I'm a closet Republican. Steve has had to reassure me a lot that he's not going to have surgery.

*Lynette:* It's been difficult for me because I'm not bisexual. I oftentimes wish I were. It would probably make life easier. We have a lot of friends who are bi.

*Steve and Lynette met in grade school and have been married for fifteen years. Several years ago, he decided to embrace his transgender existence and started receiving hormone injections. They are devoted to staying in a monogamous marriage.*

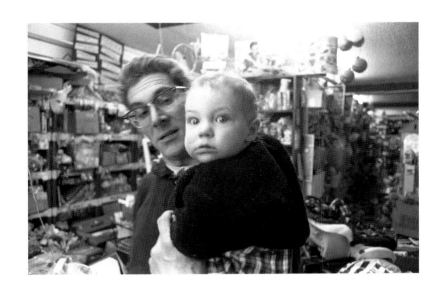

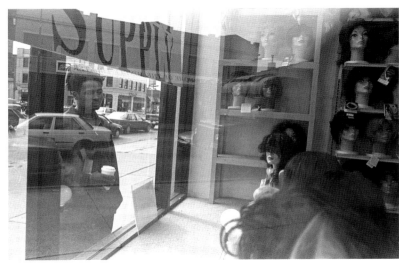

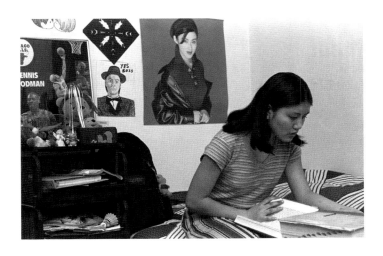

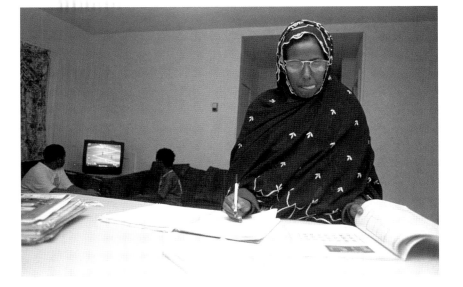

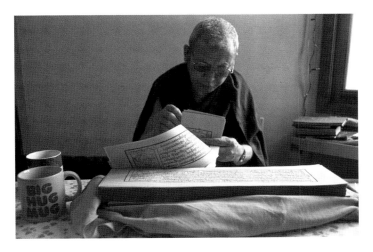

We are Somali people. We thank the American government and the American people, because when we came here, we had nothing. And now we are okay. We have a place to live, we have everything.

My husband has a health problem. He was injured in the civil war in Somalia. He has a bullet in his head. The hospital told him they can do nothing. If they take the bullet out, he can die. He is like many Somalis who have injuries from the war—people who are blind or missing arms and legs. After the war, when we came to America, he changed. He had this craziness. He was always nervous. He would look under the bed. He would just get mad. This was not the man I loved. This was a completely different man.

After a while, he killed someone. Another Somalian man. Now he is in jail. Two people got injured by this bullet. We don't know what to do. We can't afford a lawyer. The children cannot work because they are too young. My husband is in jail. We don't have help. That's all I have to say.

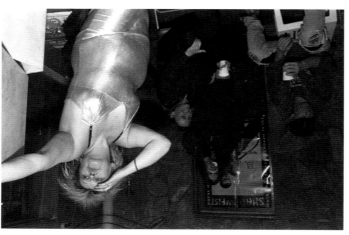

will probably try to continue to be punk for as long as I am alive. It has to do with making your life and making yourself and creating an expression that is as true as possible and not being influenced by other forms. Go with what you can to make sure there is something lethal about it and to express as much truth and originality while sort of shaking things up as you can.

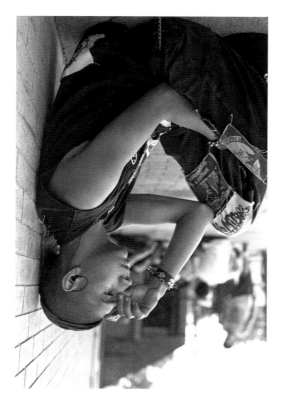

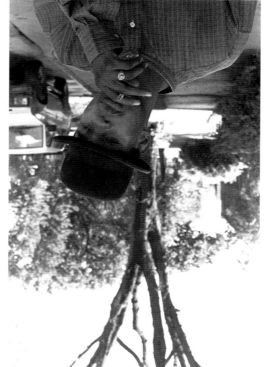

I've come a long way. I was abused when I was little. I never had no father. I've done the street life, sold drugs, you know what I'm saying. Went to jail, stuff like that. The normal things going on the corner—selling crack, whatever. In the 'hood, that's normal.

One time I filled out an application and told the truth about being in jail. You know, they say the truth will will set you free, but they didn't give me the job. That's why a lot of brothers ain't got jobs. When you've been in jail, it feels like everybody looks at you all wrong. But everybody makes mistakes. True enough, I do things that I probably shouldn't be doing, but I do them anyway. Just because. But I'm doing good. I like to write music and sing. Hopefully somebody will come pick me up, see me, or listen to me, or something like that.

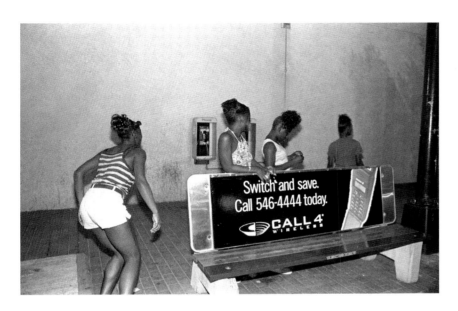 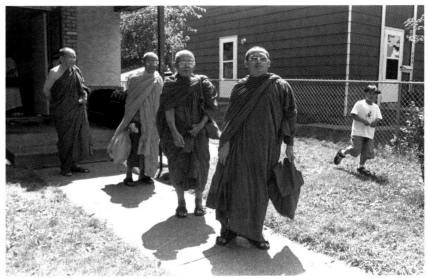

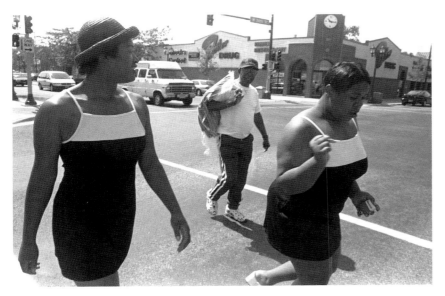

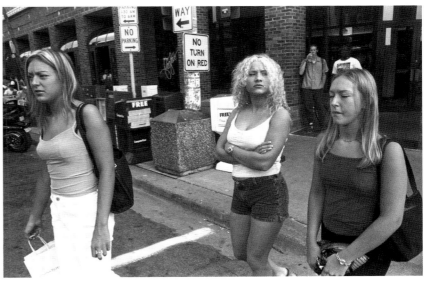

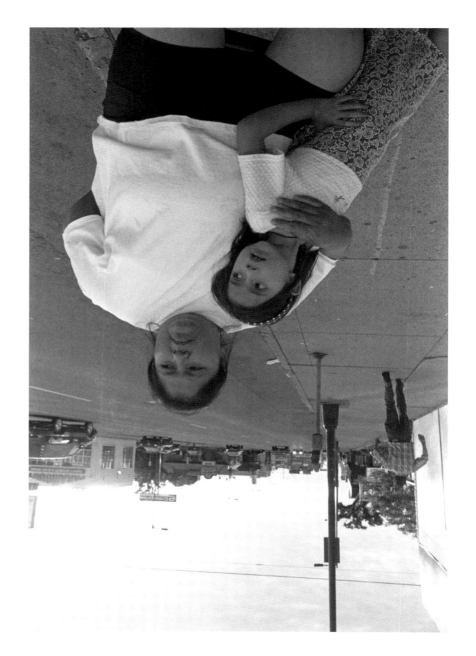

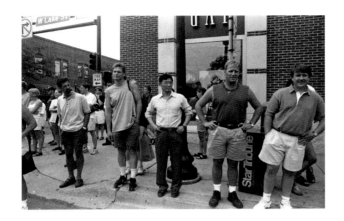

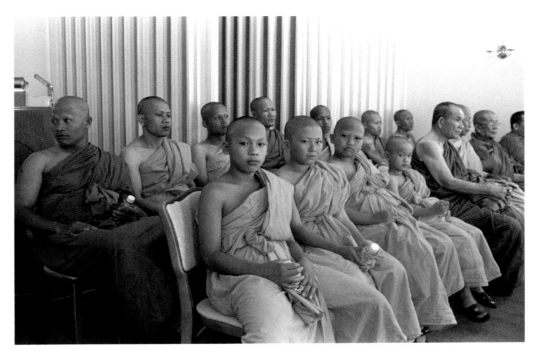

The young boys are novice, or temporary, monks. They are relatives of the family and are chosen to be monks just for the funeral service. They must shave their eyebrows and facial hair and all the hair on the head. They train for one or two days for the ceremony. They have ten commandments they must follow. Senior monks have 227.

In Laos every man before getting married, according to Buddhist belief, must become a monk for fifteen days. We believe that if your son is a monk then the parents have a better chance to get to heaven.

W e're going to a reception. We just graduated from the eighth grade from Seward Montessori Middle School. Most of us have known each other since fourth grade. We have a really good friendship.

Most of my close friends aren't white. Not that it means anything, just worked out that way. I never really thought about it. But it's a big decision when I go to college because I don't want to go to a small, only white place. I want it to be very diverse. Just because I think with different races and cultures you learn so much more stuff. It makes life a lot more interesting.

I'll never have my kids grow up in the suburbs or a small town. No matter what. Our basketball team is pretty diverse and we had to go to, like, Watertown, Minnesota. It was the most uncomfortable place. Even for me, and I'm white. They looked at me like something was wrong with me. Just because I'm with a basketball team from Minneapolis, they automatically think we're going to do something wrong. The game was horrible. The refs were horrible. They were really biased. Almost our whole team got fouled out.

We've had kids transfer from a suburban high school to our school. I hate their attitudes, it's just so stuck. They have their own general idea on how we are and how we act and should be. They think the girls are sluts—that they play the guys—stuff like that. But I guess we have the same thing for them too. You can see why we don't get along.

*When I met this man, he had lost the use of his vocal cords and was using a device that he held to his throat called an electrolarnyx, which amplifies the tissue to create a synthesized, electronic-sounding voice.*

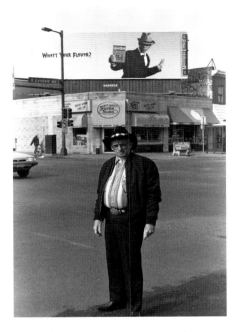

Most of 'em here call me Cowboy and that's it. There must not be too many around. At least not real ones.

I'm from El Paso, but I'm here because I've had two cancer operations at Abbott [Northwestern Hospital]. When they found the cancer, everything happened so fast I didn't have time to think about it long. By the time I went to the hospital, they told me "We've got about thirty minutes to cut you open or you're going to be gone." The cancer had wound around my vocal cords. Now I have tubes down there that I breathe through. But I feel lucky. When I get up in the morning and my feet feel the carpet, I know I'm still here. I can still communicate. I don't even consider this much of a handicap.

I made most of my living as a heavy equipment operator. But music was my passion—still is—but I can't find one of these [electrolarnyx] things that sings. I sang with Bill Monroe and His Blue Grass Boys out of Nashville, Tennessee. Sang for thirty-five years. In a month I'm going to Chattanooga. I'm just going back to see if some of those people are still around. I miss singing. It was a big part of my life.

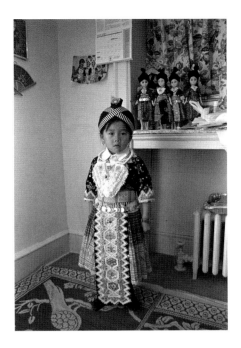

Hmong grandmothers like to dress their young Americanized kids like this to remind them of their own culture. Many old people also make costumes for dolls because they are very lonely. They keep the dolls around the house so they can feel better. They never had to make them in Laos because they wore these clothes daily.

Now they don't wear them anymore, except for special occasions. When they come here they don't feel comfortable to dress in their own custom. They think that if they wear it on the street people will think this person is crazy. It's very difficult. Back home they had all kinds of daily tasks to help their family to survive. They made their own decisions.

Here they feel locked up. One elder says she sits all day watching her watch. "I cannot dial a telephone," she says. "I can't talk to nobody. My neighbors are American. I'm afraid to be outside. I could be robbed, someone could beat me up or push me down. I could get lost and not be able to get back home." She cannot drive, she doesn't know where to get off on the bus. She sits on the couch by the window and watches cars go by every day.

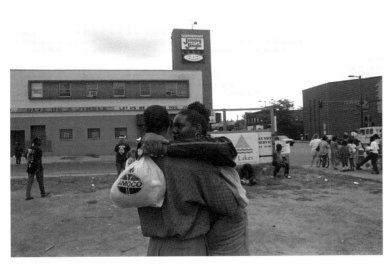

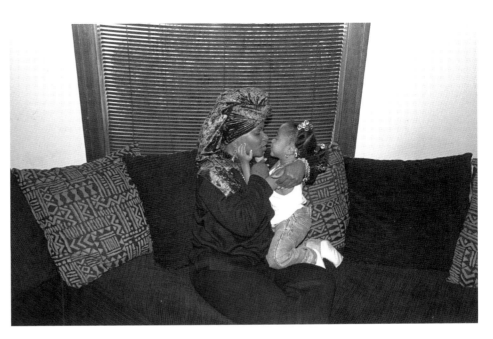

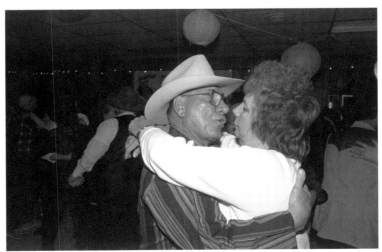

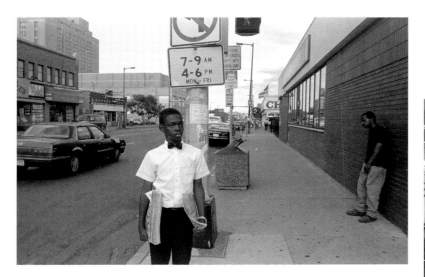

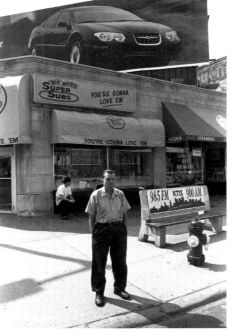

My son was eleven when he became a member of the Nation of Islam. He's out on the street offering our paper, the *Final Call,* for a one-dollar donation to defray the costs of producing the paper. This corner is highly trafficked in alcohol, drugs, and prostitution. He's really just trying to be a positive influence and show that there's an alternative.

If you are trying to talk to people and show them that there is a better place and a better way, then you want to present yourself in the best manner. The suit and the bow tie are deemed professional. If you dressed the same as others, then the level of consciousness for them to listen is not the same. Opposites attract. You don't ask someone who's homeless how to buy a house.

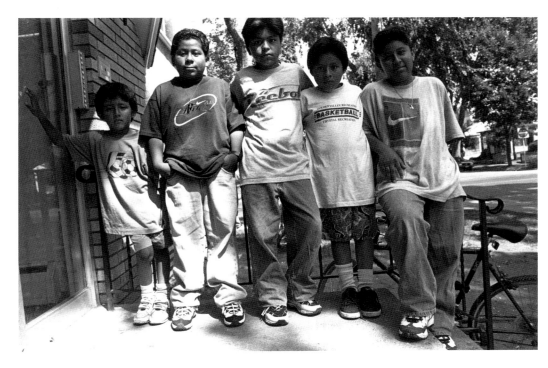

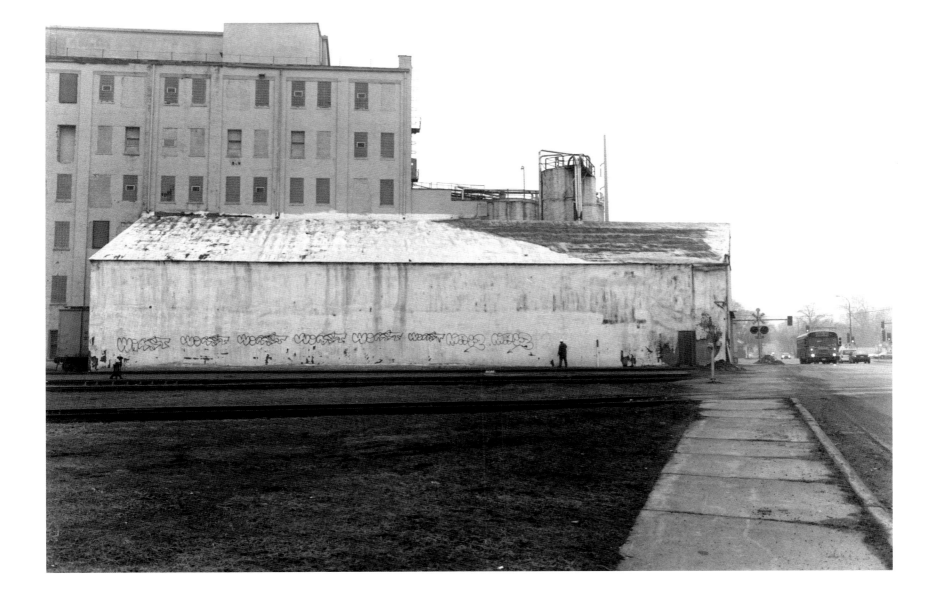

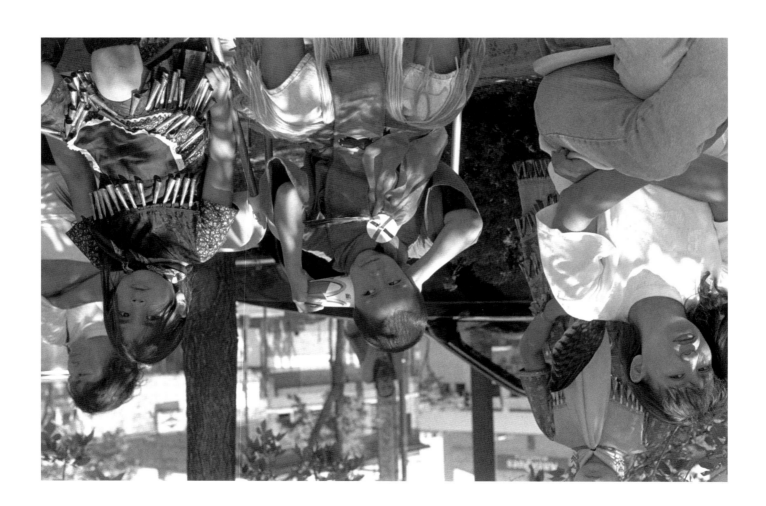

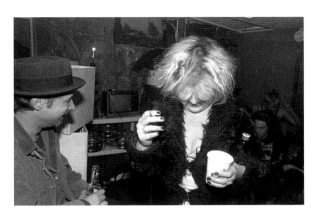

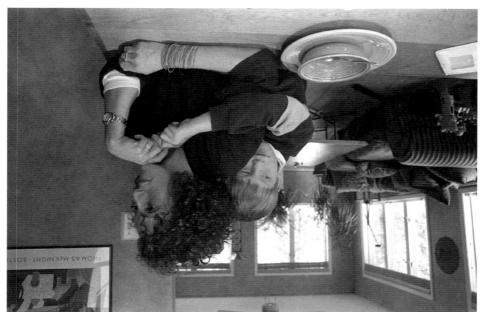

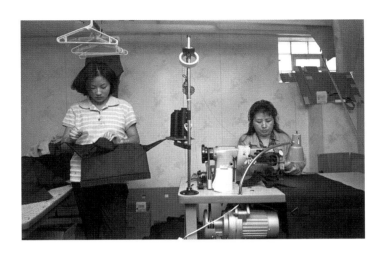

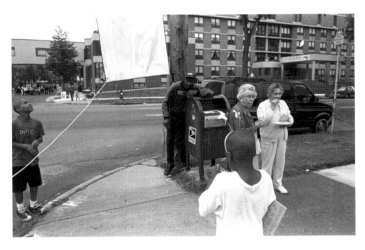

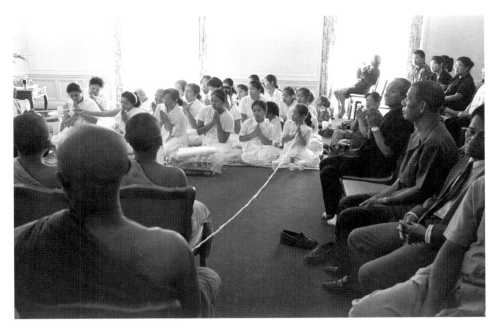

Because we are Lao, people come to a funeral even if they do not know the family. Usually three hundred or more attend. The monks, who have the highest ranking, sit on one side. The ladies in white, who are second to the monks, sit on the other side. No one is allowed to touch either of them during the service. The rest of us dress in black, women on one side and men on the other. The monks make a long string that everybody holds on to at the same time. We use it to pull the spirit to heaven.

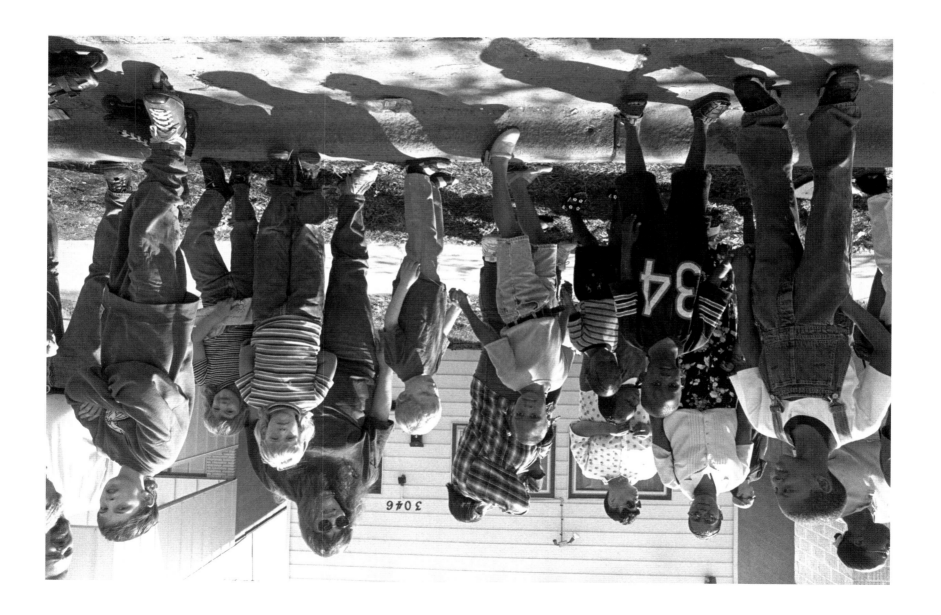

  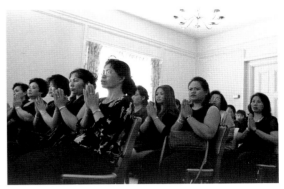

  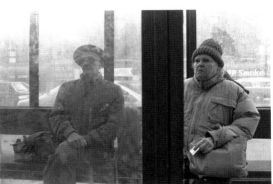

I feel privileged compared to a lot of people in this world, even though I'm considered poor in my own country. People throw so many things away. I feel lucky that I was born in this country where people throw away food every day and you can find it in a Dumpster. You can walk down the street and find TVs, radios, stereos, clothes. Anything you need to survive. I don't like waste. If you ask someone for a hamburger that they are going to throw away, they would much rather throw it in the garbage and not give it to you. I don't think that's right.

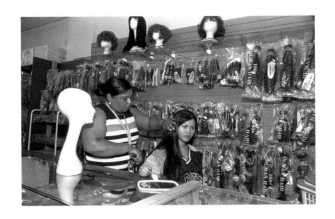

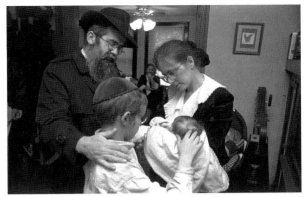

All the good human hair comes from China. They have these women who live in mountainous, isolated villages who grow hair just for sale. Hair has to be virgin hair. It cannot be touched by chemicals or dyes. An eighteen-inch piece of hair took at least three years for somebody to grow. They have those guys who literally go up with donkey trains into the mountains and buy the hair in bulk from these women.

Asian hair has sixteen layers of cuticle, which is the skin layer. Caucasians have four layers of cuticle. Africans have twelve. Caucasian hair is ovate. African hair is real flat, like a blade of grass. Asian hair is perfectly round. So to make Asian hair simulate African hair, they have to shave off four layers of cuticle. To simulate Caucasian hair they have to take off twelve layers. Blond hair is the most expensive because in the dyeing process some of the hair gets damaged. It takes more raw product to make blond hair than to make dark hair.

I cannot tell you how many people are shocked and amazed to see that my family has always lived within two blocks of Lake Street. For many years the so-called leaders of the Jewish community have said that the only low-income Jews are Russian immigrants, or that the only Jews who lived in South Minneapolis lived around the western lakes or Uptown. So what is wrong with us who live near Lake Street and not in the suburbs where they do? They seem to have decided for some reason that there aren't any lower- or moderate-income Jews. The Jewish community has bought the stereotype that all Jews are rich. It's a strange dynamic.

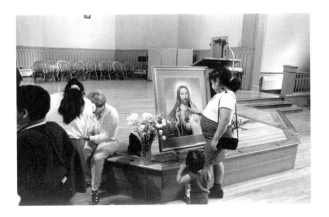

*This Tibetan monastery was in a small one-bedroom four-plex. In one corner was a television set. I mentioned to the younger monk that there seem to be a lot of commercials that show monks driving SUVs, using cell phones or laptops. I asked him what he thought of that. "It's all good," he replied. Then he said that most people think monks are vegetarians. They should be vegetarians, he said, but in Tibet where he grew up the climate was too cold to grow many vegetables. So he eats meat.*

Buddha taught that one should not kill to eat, but we had to eat something to survive. But we buy our food at Rainbow [Foods] and the animal is already dead.

Motivation is the key to understanding action. One's action might be bad, but the motivation might be good. One's true action is very hard to judge. Monks should be wise. They are studying ultimate wisdom. Am I wise? I wish [laughs]. I took a vow to control myself. When you become a monk you are not enlightened. You have the same delusions as anyone.

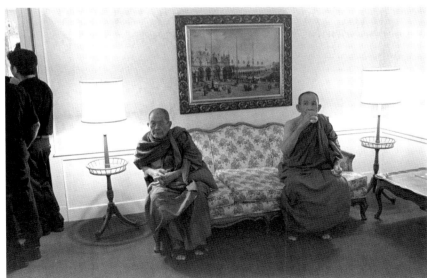

We've adopted four children. We decided to adopt because we couldn't have our own kids. Many people come up and tell us we're angels for doing this. But we didn't do this for our sainthood. We did this for selfish reasons. We just wanted kids. And our kids are just a blessing. We can't imagine life without them.

We get asked questions everywhere we go, especially by kids. "Why is she black?" And I say, "That's the way God made her." And they say, "No, no, no, you know what I mean." Or they say, "Why are you white?" I think once you develop a relationship with people it doesn't matter. But people have their own ideas and prejudices. I think we're kind of a puzzle to people. Ninety-nine percent of the people respond positively.

Sometimes we would like to blend in. Almost everywhere we go we're asked questions because our family stands out. There's always the feeling of having to explain our family. I'm sure it can't help but make the kids feel uncomfortable. Sometimes I get tired of it. But then again we like to talk about our kids too.

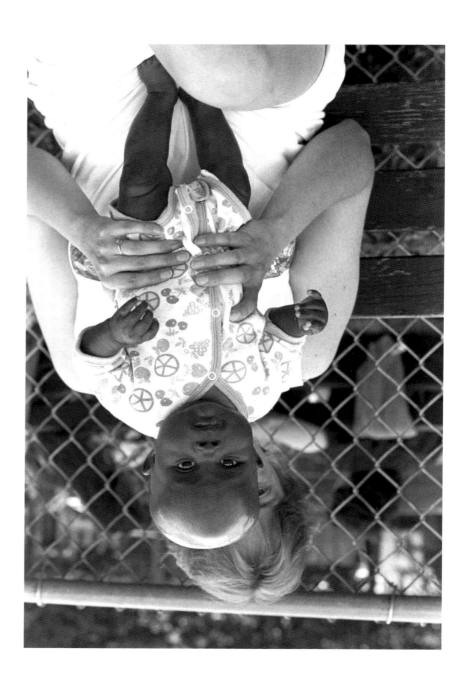

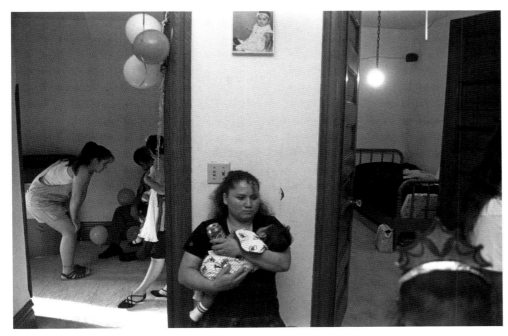

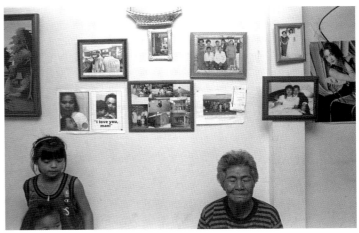

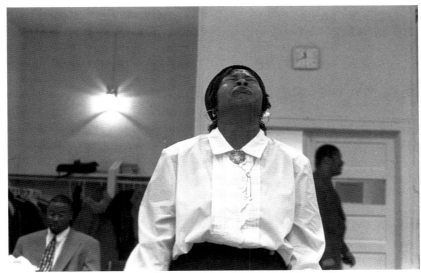

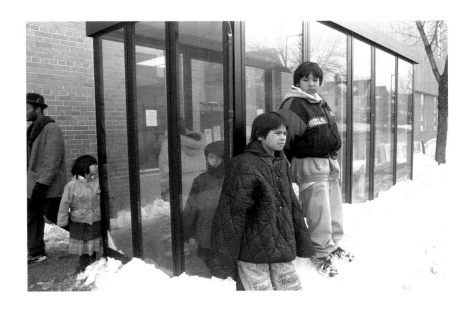

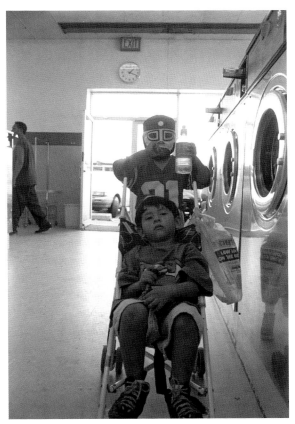

We are Sami, the original inhabitants of northern Scandinavia and the Kola peninsula of Russia. We feel a kinship with other indigé-nous people. Our culture is very similar to some Native American cultures. Our grandparents were nomadic reindeer herders who lived in tepees. In European liter-ature, we are often referred to as wizards, like the Gypsies.

We are white people, but we do not consider ourselves European. Because we have a mix-ture of Asian and European characteristics, we are regularly mistaken for being Oriental. When we were on our honeymoon, the first thing we heard was somebody saying, "I didn't know they allowed Chinese in here."

Because the pressure from the Norwegian society to assimilate was so strong, our parents did not teach us the traditional Sami language. You were not allowed to own land if you didn't speak Norwegian. Samis were treated like Native Americans were treated here. We were forbidden to speak Sami in public schools until the 1960s.

But we never acted Norwegian or spoke Norwegian at home. After we emigrated to the United States, our friends were black, Asian, American Indian, or Jewish. We just felt more comfortable around non-European people. I served on the committee of the NAACP [National Association for the Advancement of Colored People] for many years.

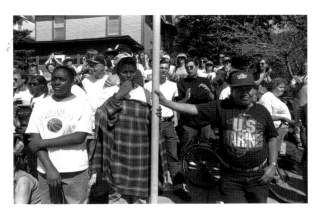

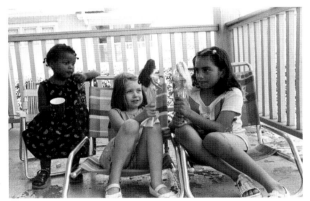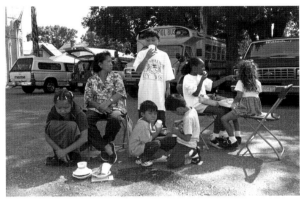

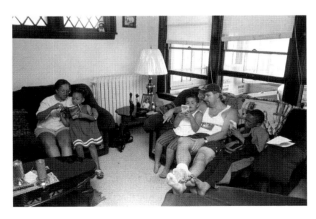

My name is Psycho. The police gave me that name. It's kind of a messed-up label. Sometimes I do wrong, sometimes I don't. The land takes care of me, and I take care of the land.

The people out here is normal. People just put them down all the time. They human beings too. Just because people get high, smoke crack, stuff like that. Everybody got some kind of faults in their life. Ain't nobody perfect. We do what we have to do to survive. I just go in Psycho's land. This is Psycho's land. Whatever goes wrong goes wrong.

I try to keep things from going wrong. I stay with my mom off and on. My mother is a church lady. I'm the outcast of the family but very loved by all of them.

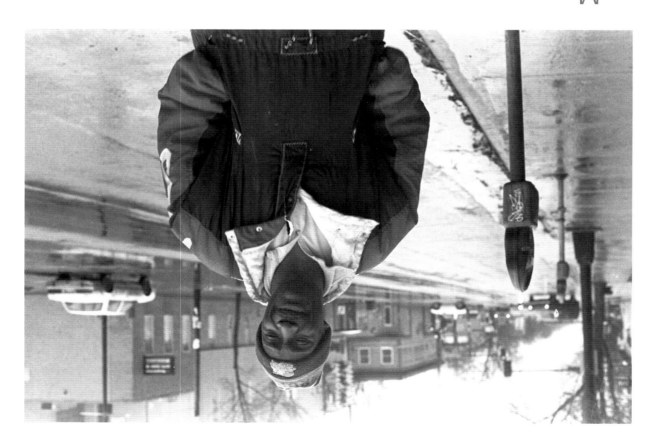

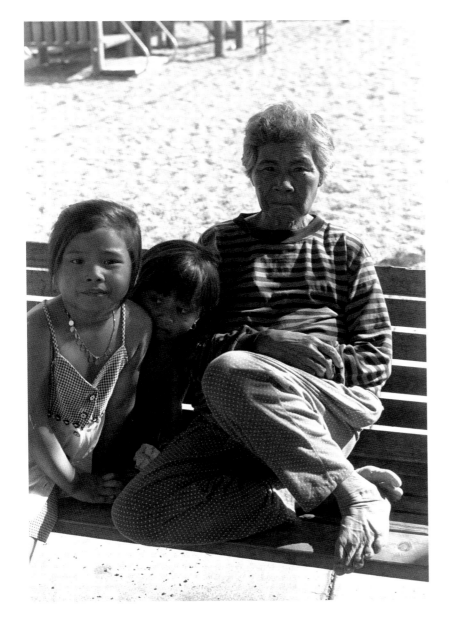

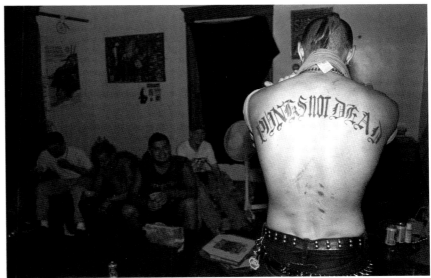

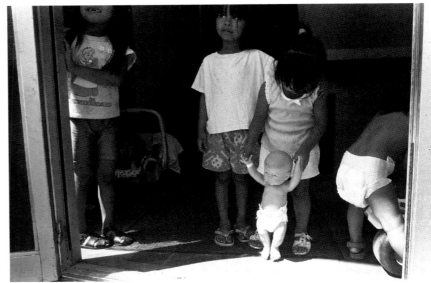

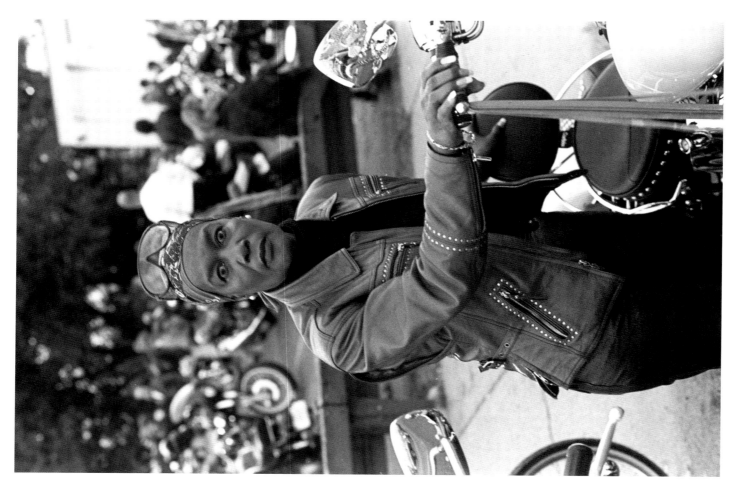

We meet the first Thursday of every month at Dulono's Pizza. I ride a Harley Softtail Classic, 1997. I didn't start riding until I was fifty-three. It's like living on the edge, like parachute diving. I also love the camaraderie.

Motorcyclists are some of the nicest people you'll ever meet. We really look out for each other. A motorcyclist wouldn't dare pass an-other motorcyclist if their bike was broken down. I wish everyone on this planet treated each other the way motorcyclists do. We wouldn't have gang killings. We wouldn't need Title XII. We wouldn't need the Americans with Disabilities Act. One thing about motor-cyclists is that they don't discriminate. All they care about is the drive.

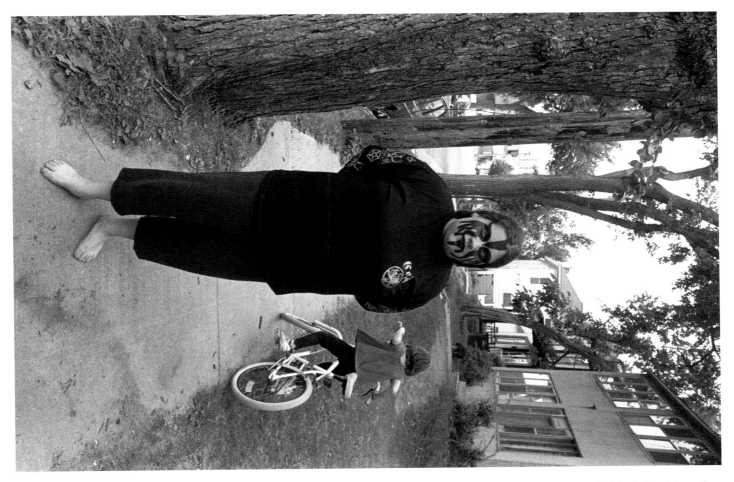

The idea is to try to look dead or unholy. I got sort of tired of the way I looked every day. I do different designs all the time. Sometimes I put it on and walk around outside and see how people react. It's fun.

I listen to death, black, some speed metal. I've been listening since I was eight. My sister got me started by playing KISS, Ozzy, and Black Sabbath. I like the way it sounds. It grabs you by your soul. It's sort of like in Africa when they do the voodoo dance. It feels good.

I live at home with my mom. She doesn't mind my music. She figures that as long as I don't try to join gangs or deal or do drugs it's okay. I like to watch cartoons a lot. Comic books. Play with my kitty cat. Basically watch TV. Play video games. I dropped out of school. I don't regret it at all.

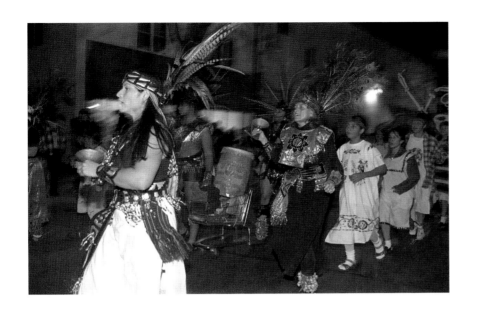

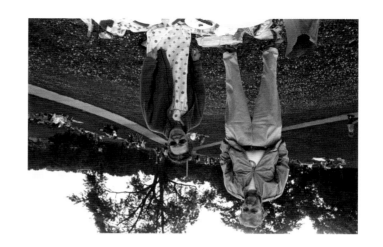

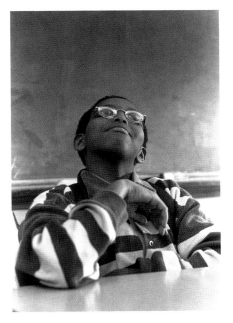

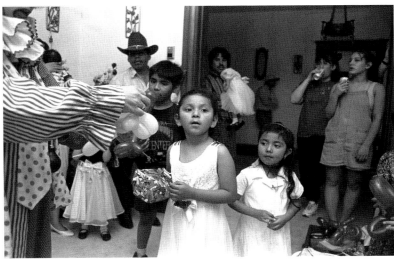

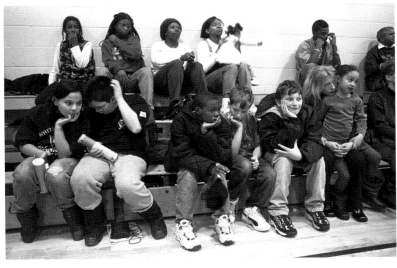

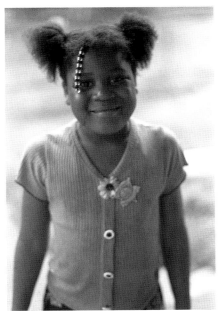

The Braid Factory is Ethiopian run and owned. Most of our customers are Afro-American, and some white people too. We learned when we were young in Ethiopia, but now it is a business. It's very popular now. People see it on TV. Singers, rappers, basketball players. There are zigzags; cornrows; twisted; dreads; Brandy braids, like the singer; and human hair or synthetic extensions. It can cost from $100 to $200, depending on what you want. It takes four to five hours and lasts for several months before you have to do it again.

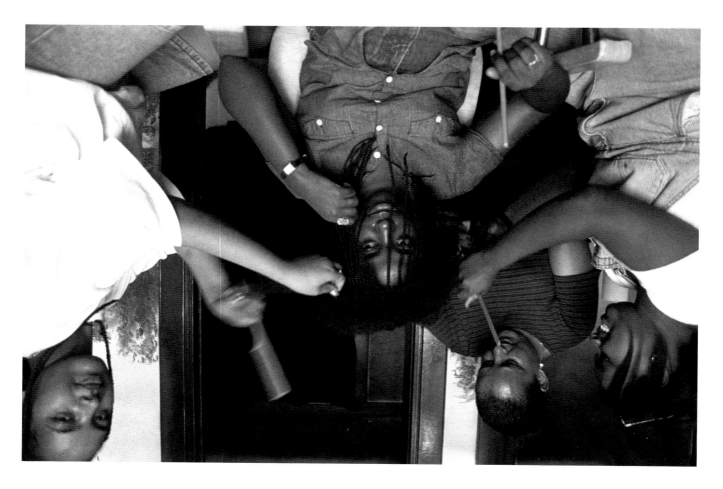

*A customer, who declined to be photographed:* My momma started me braiding my hair. I just don't like to do my own hair because it takes too long. You do it to pamper yourself. Everybody I know who comes in here, their hair be on hit. You know what that means, right? It means it's the bomb. It means it be straight. It means it be looking good. Anybody that don't know what that means I can explain it in about five different ghetto terms. Now you know.

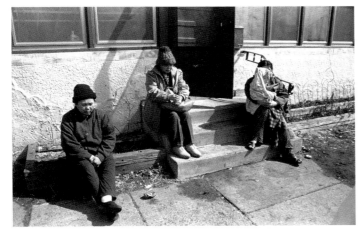

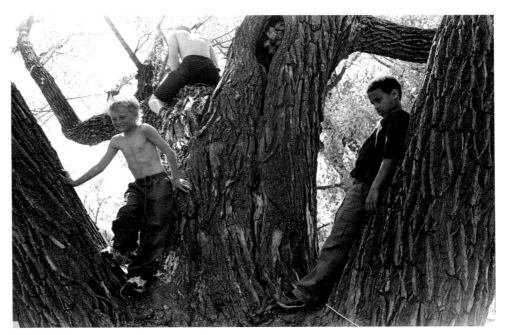

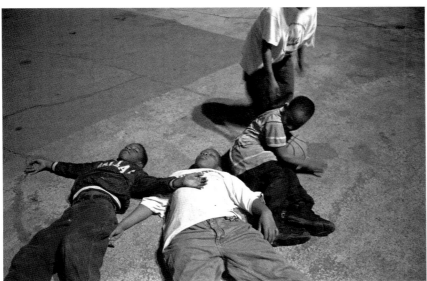

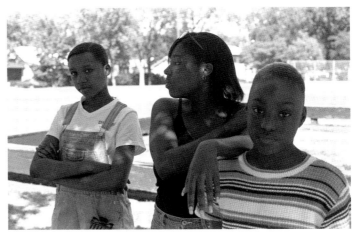

Blaine sucks. I hate it more than anything. I don't think I belong there. All the people there are all, like, I don't know, they're all suburban kids. I mean, I hate to stereotype people, but they're all ducks. They're all, like, preppy kids and cheerleaders and stuff. It's really hard to be a kid that doesn't have a label, and doesn't want one. We get ridiculed all the time.

Nobody really dresses like us in Blaine. Everybody is, like, always trying to be somebody else. They're always trying to be somebody that they're not. That's what we're not about. Being other people. We hate other people. We really do. I hate people.

Most of our friends are in Uptown. All the guys I've dated from Minneapolis are so much different from the guys I've dated from suburbia. Everybody that I've dated from Blaine always had money, always had both of their parents live with them. One boyfriend that I had in Minneapolis, his family lived on welfare. He had, like, a whole bunch of sisters and brothers, and all of them had different dads. That was a cool experience for me.

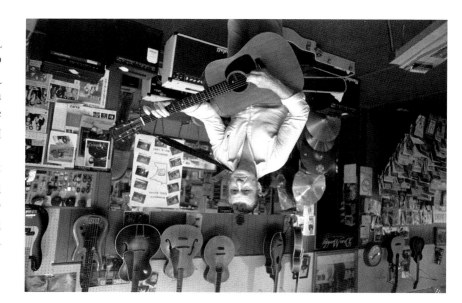

We have a session here every Saturday morning. Anybody who wants to play is welcome. We sing our songs, which I love to do. I've been singing all my life, since I was five years old. Worked down here on Lake Street about thirty-five years ago. We had little remote radio broadcast. Had a group called the Circle Dot Ranch Boys. I tried to make a living at it for a while, but it just didn't work out.

I sing from my soul and heart. There are two songs that when I sing I always break down and cry. One is called "Old Shep." It's about a dog that a person had to shoot. The other is "Be Careful of the Stones You Throw." Just even talking about it gets to me. Every chance I get I come down here. If I'm singing, I'm happy. I'm not singing, I'm not happy. That's my life. Actually it's about all I live for.

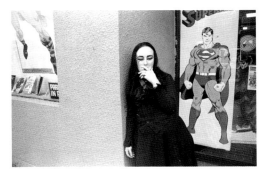

I only wear black. I try to go for a Victorian kind of a thing, but it's hard to do because it's hard to find and I don't have the money. I phased all colors out of my wardrobe during my sophomore year of high school because I was unhappy with the way I looked. Before that, I looked like everyone else because of peer pressure. Dressing myself in this fashion gives me emotional enjoyment. I think it's beautiful. My appearance goes along with my personality anyway. I'm naturally introverted. I don't like very many people in general.

A lot of people think I dress this way because I want attention or because I want to rebel against my parents. Or they think that I'm into S & M or that I'm a witch or whatever. I get a lot of really rude reactions. People will yell things out of their car. I think people feel a need to diminish what is different to make them feel better about themselves. It's sad that with so many different forms of racial and sexual diversity that everyone is still hung up on a hegemonic set identity, instead of looking at acceptable differences.

I go to Dreamhaven because they sell some of the darker type of underground comics that I like. I read *John the Homicidal Maniac*. It's about this boy who has mental problems and kills people for the random nuisances that they cause him. I find it amusing because a lot of the problems that he has and a lot of the comments he gets from people are similar to those that I get. It's a little bit of a release for me.

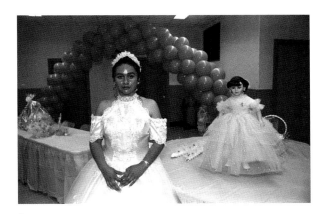

I was born in Mexico. In our culture when you turn fifteen, you have a quinceañera celebration. It is when a young girl comes into womanhood. I feel elegant and proud. I give God thanks that my family is able to celebrate this tradition. Even though I am still dependent on my mom, I now feel more dependent on myself. I don't think like a child anymore. People respect me now. They look at me as a mature adult. This also gives me the green light to date and have boyfriends.

It's also part of the custom to be given a dressed-up doll. It signifies that this will be my last doll, the last toy that I will receive. Now if I am to receive a gift, it should be a gift for a woman, not a child.

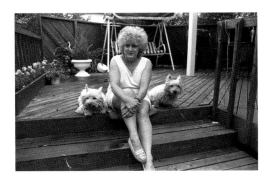

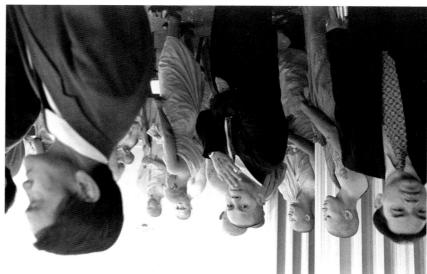

*Minnesota has one of the largest Laotian communities in America. Most of the fifteen thousand live in the Twin Cities.*

We were forced to come to this country suddenly, without preparation, when Vietnam fell in 1975. Cambodia and Laos worked secretly with America. We weren't neutral. We were supposed to pull east or west. But we had the same enemy, we didn't want communism to take over. When we first came, we took whatever work we could grab. Many worked more than two jobs. Most had a big family to support. Now our children are going to college and becoming engineers and lawyers.

I've been here since 1961. I specialize in invitations and stationery. I went to Dunwoody [Institute] in 1945. I started in '48 in my basement out in Richfield. The way I do cards hasn't changed a lot, but in the world, new processes have come along with these computers.

My walls are filled with framed sayings. I was just monkeying around. Once in a while, somebody wants to buy one. I put them up to cover the dirty spots. My favorite is "Statistics show that one who has a daily exercise plan dies healthier."

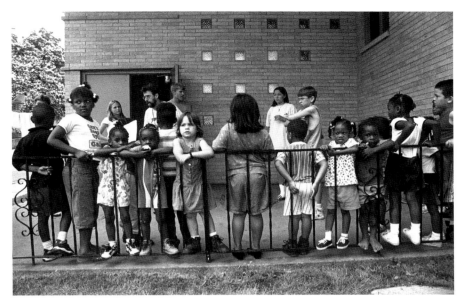

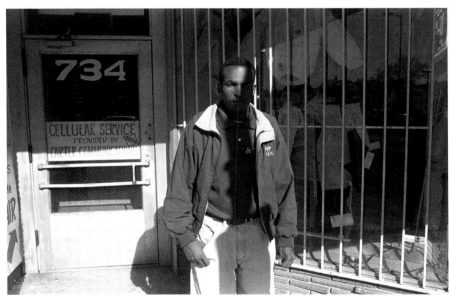

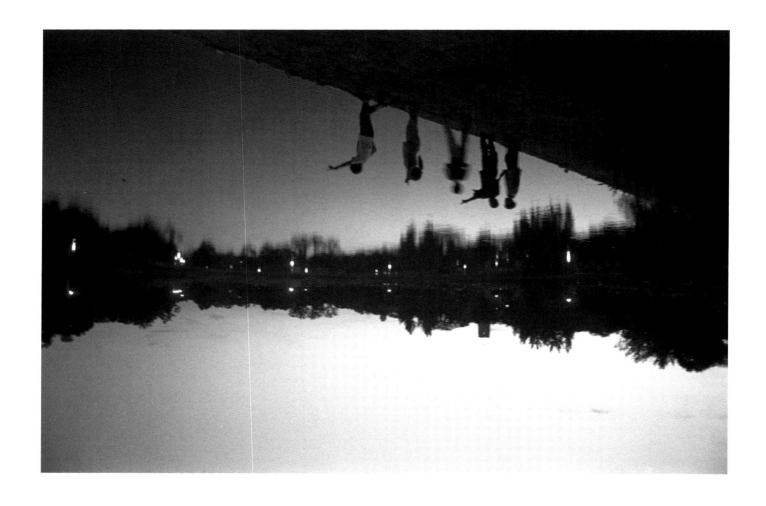

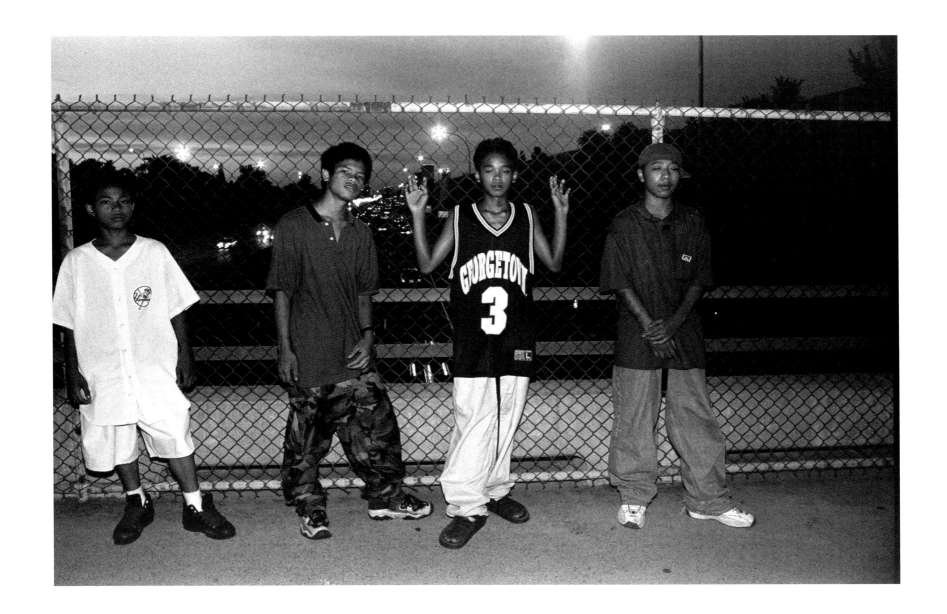

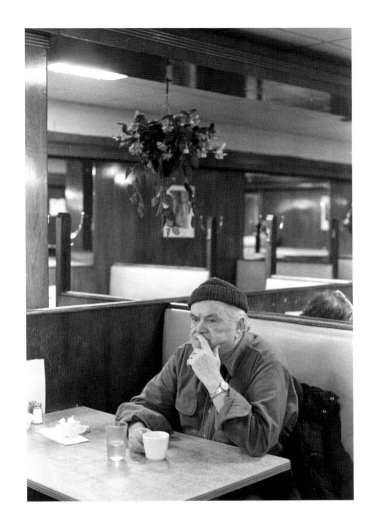

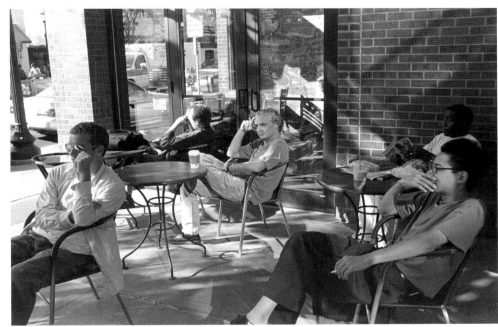

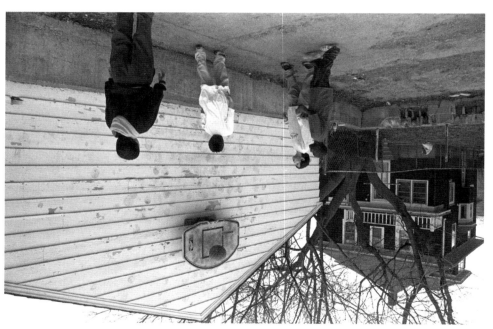

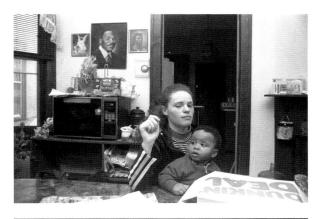

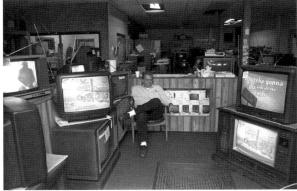

Shree Satyam Mandrr, which means the great temple of truth, is our Hindu place of worship. Our main god is Shiva, the almighty one. Shiva takes on many forms, like Lashmi, which is the goddess of light. Or the elephant-headed Ganesh, the god of knowledge. There are 108 forms that we pray to.

My mom started the temple in the basement of our house. We moved twice, each to a bigger place. Now sometimes we get over two hundred people here for special celebrations.

I was born in Suriname, which is next to Guyana, where most of our people are from. We moved here from Brooklyn after my brother's friend got shot. It was too rough. Living in Minnesota has been the greatest.

I'm a junior at Roosevelt High. It's a great honor to be in a society with so many different cultures. At our school, you've got the Hmong Society, the Islam Society, the Hindu Society, and the Christian Society. We have a multicultural club where we try to sort out a lot of our cultural differences so we don't with fight each other.

Things are a lot different from my parents' generation, where there was a lot of religious grappling. I think my generation is coming together. We're starting to make some kind of glue to paste the puzzle down.

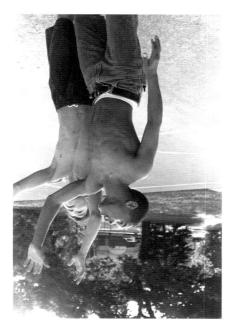

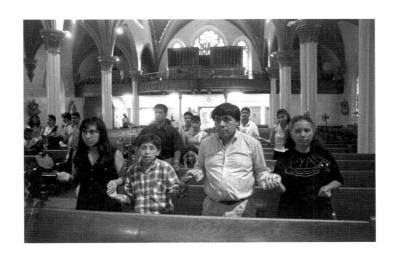

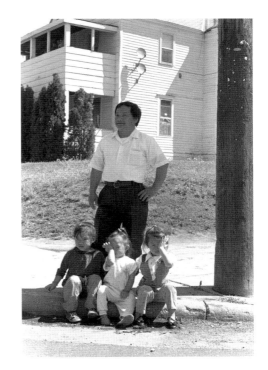

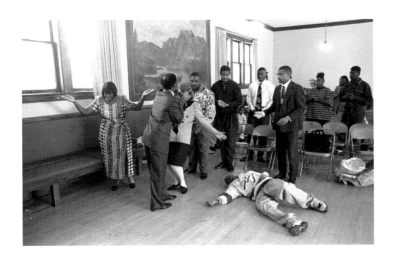

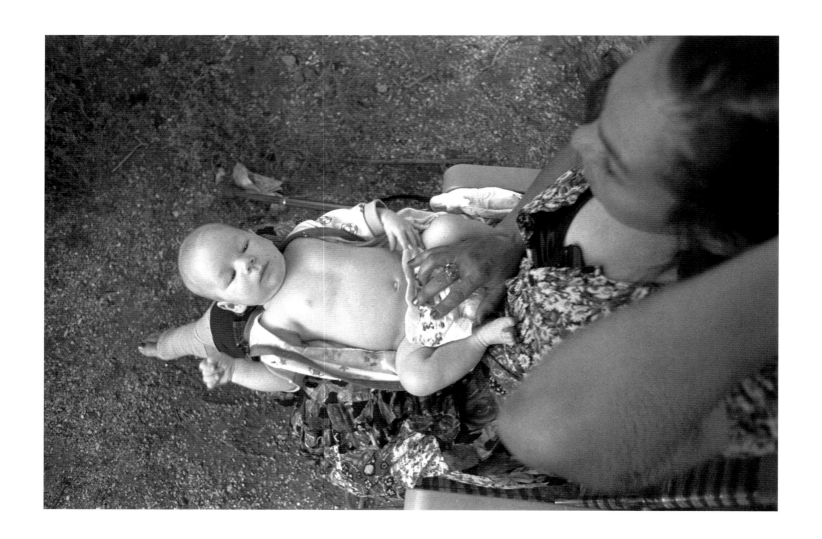

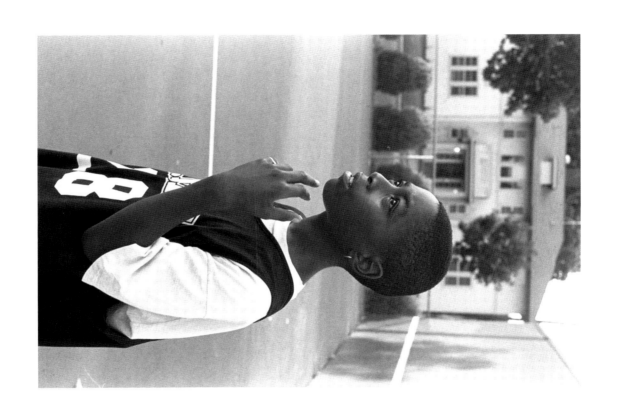

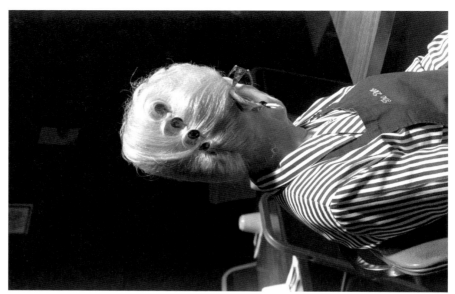

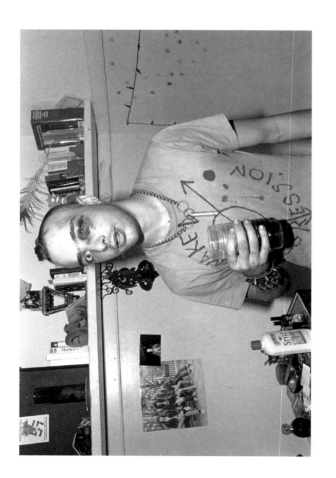

I went to Wisconsin to get a keg. Stopped off and saw a party going on. Started drinking with a bunch of hillbillies, I guess you call them. Beat the crap out of me. They held me down to the ground, kicked my face, kicked me all around. I maced them, made it all out of there, made it alive, and now I'm here drinking beer.

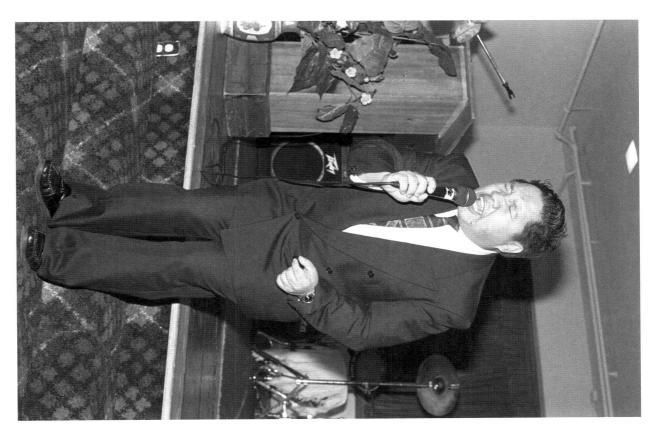

The first time the Hmong heard about God was when the CMA [Christian Missionary Alliance] came to Laos in the 1960s. Our church is the Hmong New Life Victory Assembly of God. We're Charismatic Pentecostals. We speak in tongues. We believe in faith healing, the resurrection of Christ, the rapture, everything.

Traditionally the Hmong are animists. They believe in ancestral spirits. In America it is harder to practice shamanism and sacrifice animals. Besides, the young people don't know the traditions anymore. The animists are very strict. You have to do the ceremonies in exactly the right way or else you get in trouble with the spirits. It's much easier to go to church, pray to God, read the Bible.

It's tough because the older people believe that when they die their spirits still live on. They want their children to remain animists so they can feed their spirits when they die. They'll kill a chicken or pig and give a couple of sacks of rice. They put it on the table and offer it to the spirits. I don't eat the meat that they offer to the spirits. I just eat the vegetables. Some people don't like that. They will say, "You are not part of the Hmong. You don't like the Hmong." It's a problem, but to me, nothing's perfect in life.

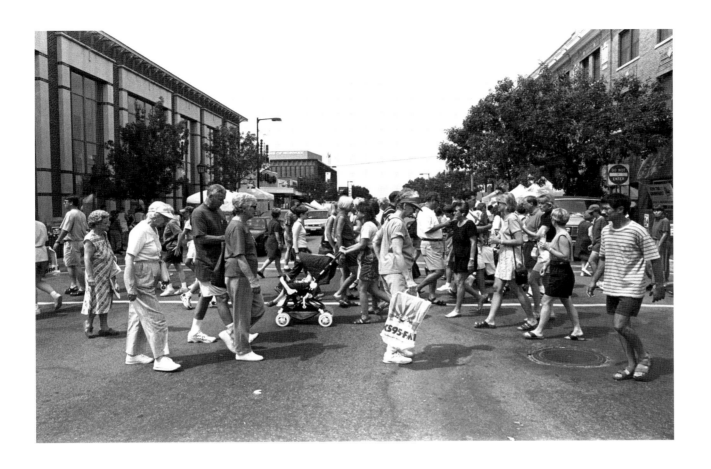

Switch and save. if 646 4444 today

IN

TRUONG TRANH
CUSTOMER
PARKING

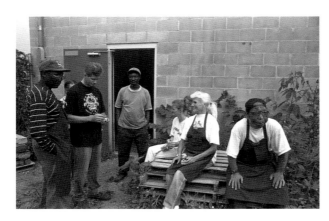

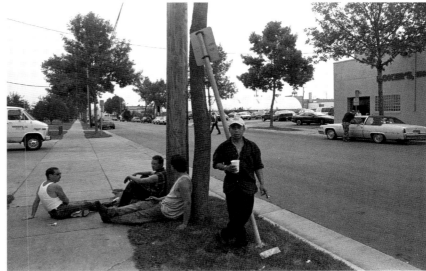

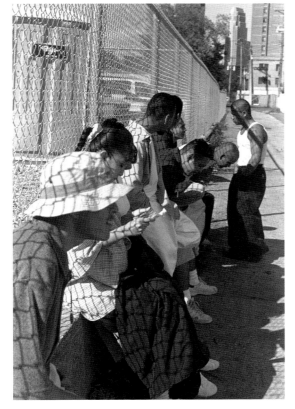

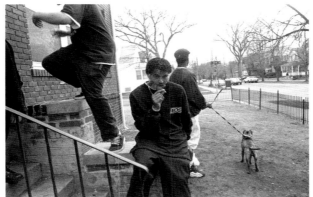

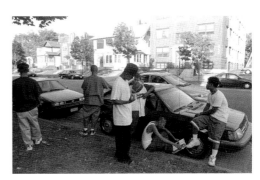

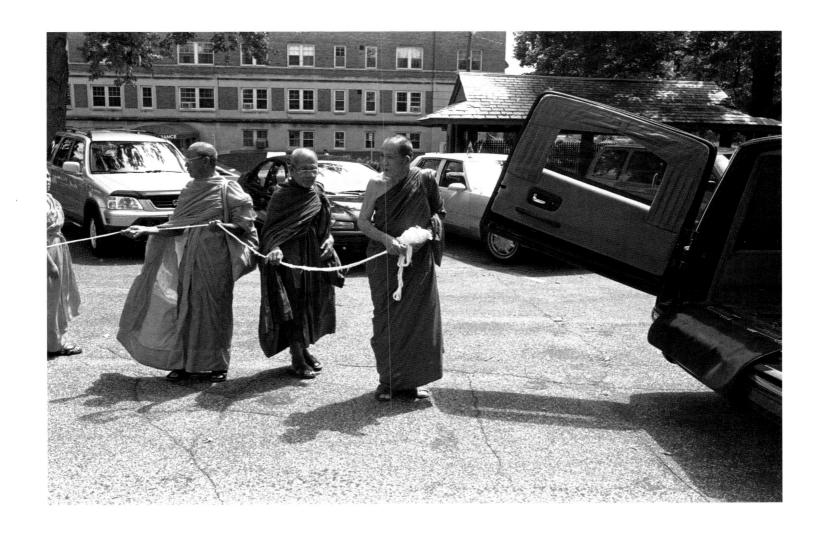

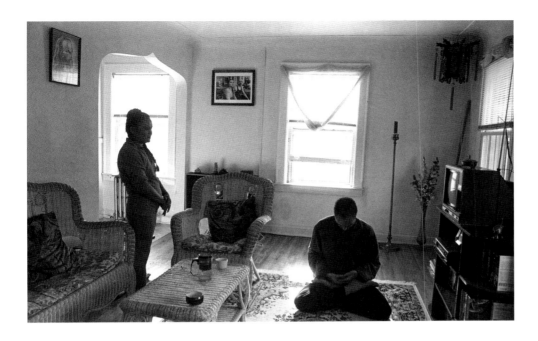

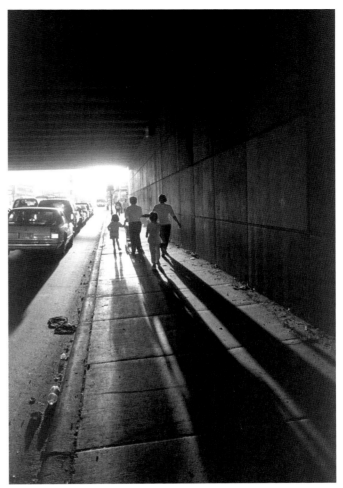

I'm from Thailand. I met my husband twelve years ago in Hastings, Nebraska. We were in a tavern playing pool. When I beat him, he had to put in thirty-five cents to win me back. But I won him because we ended up getting married. That night I invited him up to my apartment, and we talked until four in the morning. I cooked him noodle soup. The second night he proposed to me. We got married two weeks later.

I'm really happy with him. He's thirty-six, I'm forty-three. But sometimes we act like teenagers. We like to skate, shoot pool, go swimming, play bingo, and bicycle. For all twelve years, he never cheated on me. I never cheated on him. We love each other. We go everywhere together. We're never apart except when he goes to work. If they let me, I would probably baby-sit him there.

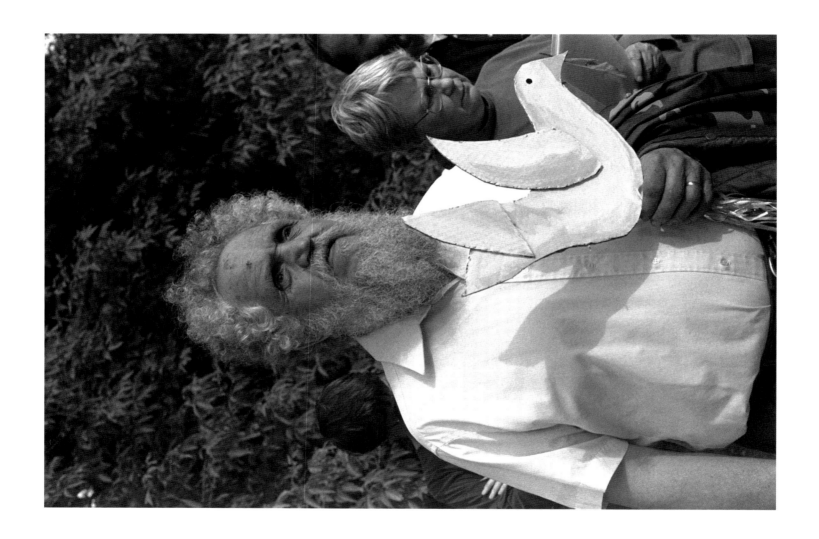

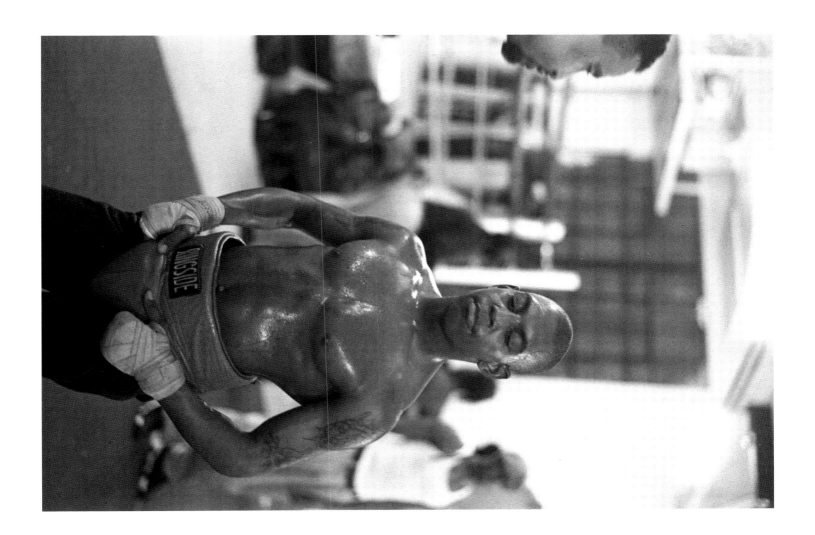

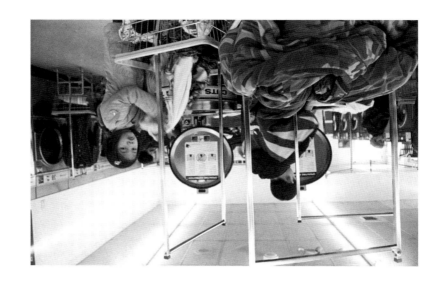

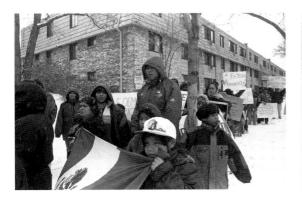
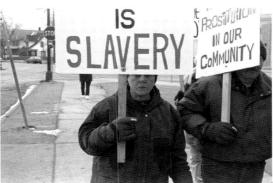
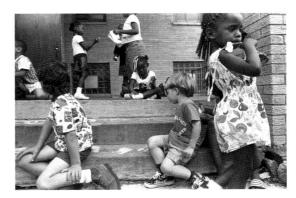

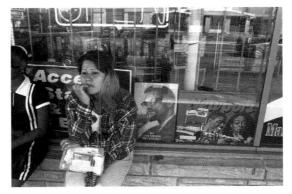
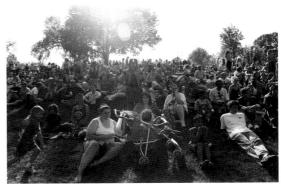

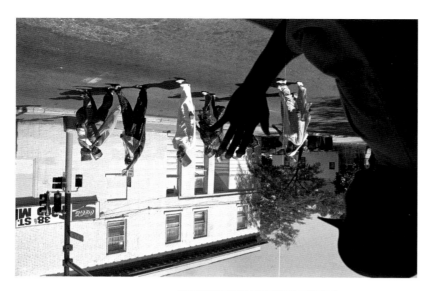
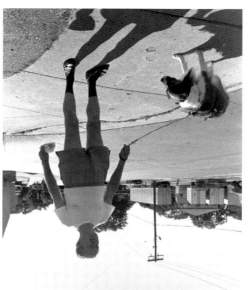
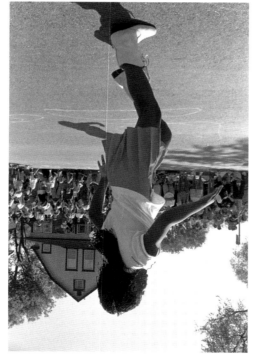
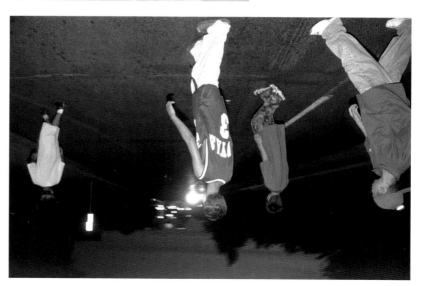

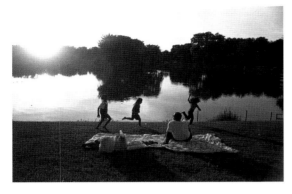
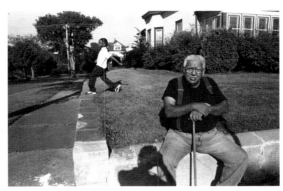
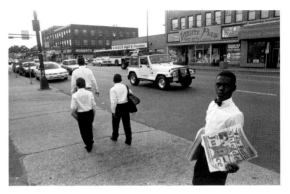
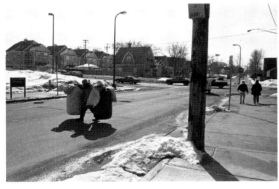
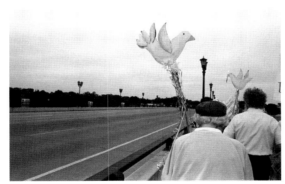
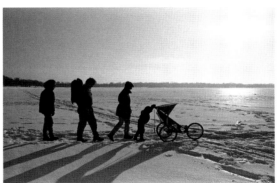

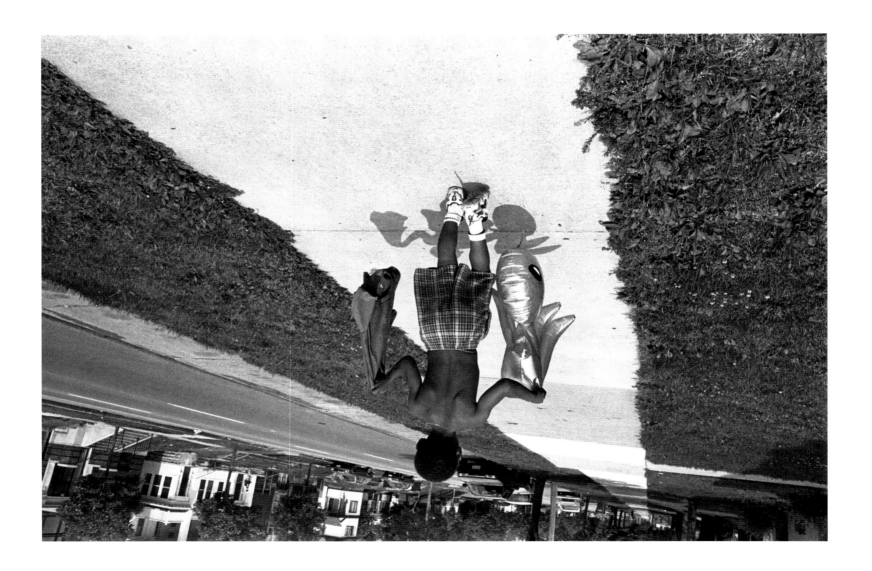